IMAGES
of America

FOX THEATRE

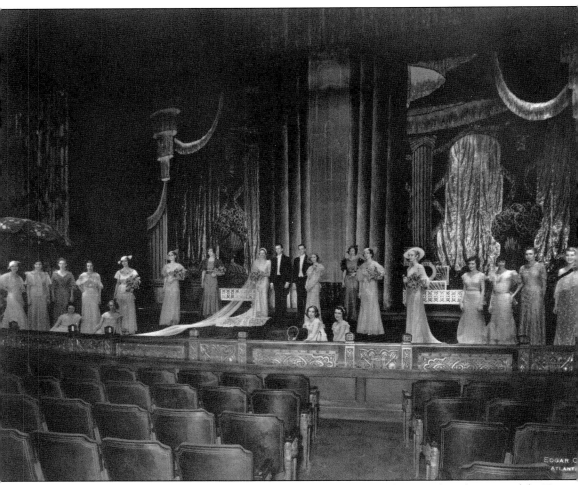

This historical Edgar Orr photograph shows a wedding being orchestrated on the stage of the Fox in 1930. It is unclear if this was an actual wedding or simply staged for the photographer. Orr was an Atlanta photographer who documented the opening days of the Fox Theatre located in the Yaarab Shrine Mosque. The Fox has hosted hundreds of weddings over the decades. (Fox Theatre.)

ON THE COVER: In March 1956, new recording sensation Elvis Presley played the Fox Theatre for two days. His matinee and evening concerts alternated with the showing of the movie *The Square Jungle*, which starred Tony Curtis. The *Atlanta Constitution* referred to Elvis as a "semi-hillbilly" but noted that his sold-out concerts were attended largely by rock-and-roll fans. (Graceland.)

IMAGES
of America

FOX THEATRE

Janice McDonald

ARCADIA
PUBLISHING

Published by Arcadia Publishing
Charleston, South Carolina

Printed in the United States of America

Library of Congress Control Number: 2012940201

For all general information, please contact Arcadia Publishing:
Telephone 843-853-2070
Fax 843-853-0044
E-mail sales@arcadiapublishing.com
For customer service and orders:
Toll-Free 1-888-313-2665

Visit us on the Internet at www.arcadiapublishing.com

This book is dedicated to Joe Patten and all of those who fought to save the Fox for the rest of us.

CONTENTS

ACKNOWLEDGMENTS

When I first moved to Atlanta, my mother told me I had to visit the Fox Theatre. Her memories of visiting it as a teenager were incredibly vivid. I, too, became enchanted with the Fox but didn't realize just how many people felt so passionately about it until I started speaking to others about their own experiences. The Fox is truly unique and, yes, fabulous.

My heartfelt thanks to the staff of the Fox who were incredibly tolerant of my constant interruptions and always willing to help. Molly Fortune and Michele Schuff, I couldn't have done it without you. I want to thank president and CEO Allan Vella for giving me the green light and Betty Reynolds at the front desk for her constant smile.

A big thank you to Joe Patten, who revived and maintained the incredible Möller organ, then worked to save the Fox. Thanks goes to Bob Foreman and Beauchamp Carr, who were so generous with their memories, and to Rodney Cook, who was my last-minute savior. I need to thank them not just for helping me but for what they did for the Fox.

Hal Doby was the ultimate Friend of the Fox and a wealth of knowledge and context from his many years as a volunteer. He went above and beyond in helping. I also want to thank Elbert Fields of the Atlanta Theater Organ Enthusiasts, Ken Double of the American Theater Organ Society, and John Riester of University of Oklahoma for their help in tracking down information about the beloved "Mighty Mo."

Others who helped me find information, photographs, and memories, as well as providing encouragement and support, include Shannon Pringle, Deborah Garner, former Fox general manager Edwin Neiss, Joe Cronk, Paige Adair (and the patient staff of the Atlanta History Center), Ellen Johnston of George State University's Special Collections department, Howard Osofsky, Barbara Lynn Howell, Ryan Miles, Steve Springer, Danny Wofford, and Robert Dye of Graceland. I also want to acknowledge that there are a host of vintage Edgar Orr photographs that appear courtesy of the Fox Theatre.

INTRODUCTION

Those who have experienced it and those who have heard of it know Atlanta's Fox Theatre by a name that is much more descriptive and fitting. For them, it is more often than not called simply "the Fabulous Fox."

Perhaps the word *fabulous* is itself an understatement. As unique as it is ornate, the Fox Theatre has been a landmark in downtown Atlanta since it first opened its doors to sold-out crowds on Christmas Day, 1929. Standing at the northwest corner of Peachtree Street and Ponce de Leon Avenue, the Fox bears more of a resemblance to a Moorish castle than it does a theater, and for good reason.

It was originally designed to be the mosque for the Yaarab Temple of the Ancient Arabic Order of the Nobles of the Mystic Shrine, better known as the Shriners. The organization wanted this to be a true showplace. The Shriners owned the land for five years, making sure it was paid off before they were ready to build. They held a contest to see who could come up with the best designs, and no one came close to those submitted by Marye, Alger, and Vinour. Thirty-three-year-old lead architect Ollivier Vinour based his designs on Shriners' symbols, as well as postcards and lithographs from the Middle East. His partner Thorton Marye claimed the designs would "out Baghdad Baghdad."

Construction began in June 1928, but as the minarets and domed roof rose with construction above Peachtree Street, so did the costs. Original estimates put the price at $1.5 million, but the detailed designs made a $2 million price tag more realistic. With costs hitting $2.4 million and counting, it was clear that the Shriners could not carry the price of their dream.

The Yaarab struck a deal with movie mogul William Fox to lease the main auditorium as a theater, and changes were made to transform the mosque's auditorium into a movie palace. The theater would be a true jewel in his movie empire. Fox's wife, Eve, is said to have overseen the task of decorating the Fox's interior. Colors, carpeting, and even custom-built furniture were brought in to keep with the exotic Middle Eastern motif.

When the much anticipated grand opening of the Fox took place on December 25, 1929, the lines of curious patrons stretched around the block. Guests entered to an experience like no other. From the moment they walked through the arcade entrance, they were greeted by intricate gilt, tile, and gilded details with colorfully painted plasterwork. Barely an inch of space escaped decoration, helping transport guests to another time and place.

Movies and live performances were enjoyed in a massive theater auditorium resembling the inside of an Arabian courtyard, complete with an evening sky painted on the ceiling above. Before the curtain rose, the sky experienced a sunset, and 96 stars twinkled as spectators oohed and aahed. Even the lounges supported the elaborate theme.

Having opened at the beginning of the Great Depression, the Fox's first years were a struggle, and the theater changed hands several times, but as theater going became a more popular pastime, the Fox proved to be one of Atlanta's favorite venues. During its heyday of the 1940s and 1950s,

the Fox emerged to become the place for movie premieres, complete with elaborate parades and themed parties celebrating each. A list of who's who of the stars of the day took their walk on the Fox's red carpet. The likes of Sammy Kaye, Bob Hope, and Abbot and Costello appeared here, and even Walt Disney himself came to oversee the premiere of *Song of the South*. If not hosting movies, the theater was hosting theatrical and musical performances. Even the relatively new music sensation known as Elvis Presley came in 1956 to gyrate his hips on stage to swooning audiences for nine shows over three days. The Shriners' former banquet hall became the Egyptian Ballroom. Located just beside the theater, it hosted dinners, balls, and celebrations of every kind.

As downtown Atlanta began changing in the 1960s and 1970s and multiscreen cinema houses became the fad, attendance began to wane. A string of rock concerts just couldn't earn enough money to pay off the theater's growing debt. In 1975, the Fox closed its doors and seemed destined to become a parking lot for the expanding Southern Bell Telephone Company. When word of its fate was made public, a massive movement rose to "Save the Fox." In a drama fit for one of the Fox's stage performances, the community banded together and fought to buy it back. Atlanta Landmarks, Inc., was formed, and through the backing of prominent and not-so-prominent Atlantans, it was able to succeed in what many had seen as an impossible task.

Its success not only saved the Fox, it breathed new life into the landmark. Thanks to the generosity of supporters, for the first time in its history, the Fox was without debt and able to become self-sustaining. Great care was taken to restore the theater and transform it back to its old glory. Once again, the stars in the courtyard's night sky shone, and the gilded surface gleamed. Its priceless Möller theater organ played to full houses.

Before long, the Fox was established as not just one of the United States' premier historic theaters but as one of its most prestigious theaters, period. These days, national and international acts book early to get a coveted spot on the Fox's calendar. Touring Broadway productions plan their sets around the Fox's massive stage.

To make sure that it never again falls into disrepair, the Fox maintains its own preservation and special collections departments. Their mandate is to preserve the history that so many have come to treasure. Even those who may never have the pleasure of listening to a live performance, seeing a movie in its massive auditorium, or dancing in its Egyptian Ballroom find themselves taking tours of the building. They explore in awe while taking in the Fox's history and getting a firsthand look at its amazing architecture. No one who has seen it will dispute that the nickname "the Fabulous Fox" is appropriate.

One

BEFORE THE FOX

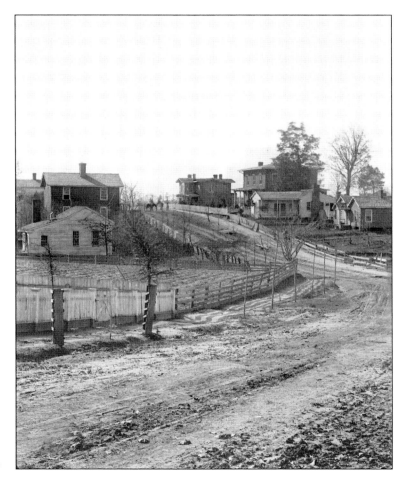

The prestigious address of the Fox Theatre at the corner of Peachtree Street and Ponce de Leon Avenue was little more than remote countryside when Atlanta was first gaining prominence in the 1800s. It was a growing railroad hub for the United States when Richard Peters moved to what was then called Marthasville to become superintendent of the Georgia Railroad. Peters had bought 405 acres of farmland located where the Fox now stands. (Library of Congress.)

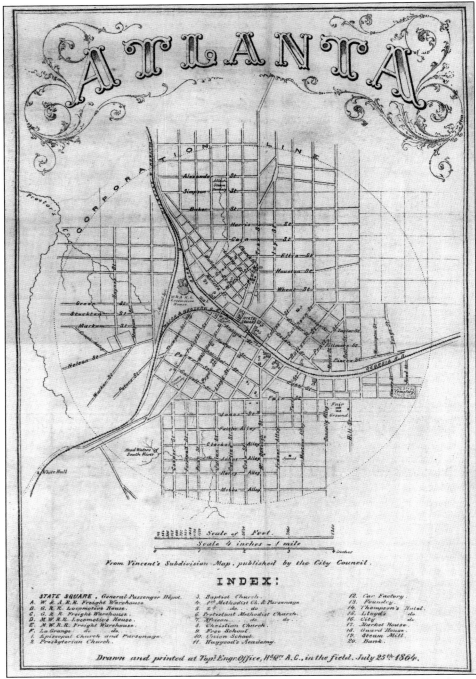

The area where the Fox stands was still well outside city limits when Atlanta officially got its name in 1857. Residents had grown tired of the name Marthasville, which had been a tribute to Gov. Wilson Lumpkin's daughter. They had been calling their town Atlantica-Pacifica until the shortened Atlanta was proposed by Georgia Railroad's chief engineer, John Thomson. This 1864 map of downtown Atlanta shows just how small the town was. (Library of Congress.)

This 1864 photograph is of Confederate Fortress K, built just north of downtown to help protect the city from Gen. William Tecumseh Sherman's Union army. Its location was where the Fox now stands. Fort K was where the road that ran along Peachtree Ridge into downtown merged with the road from Decatur. That road had been called Clear Springs but was renamed Ponce de Leon Springs some time before 1864. (Library of Congress.)

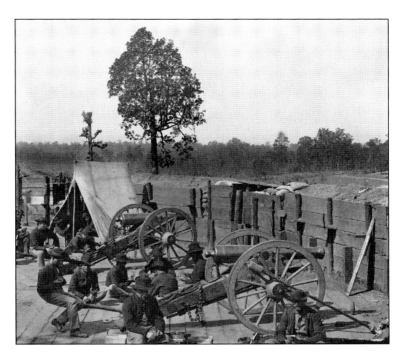

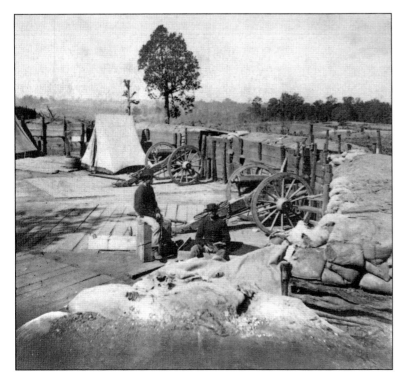

The "Big Gun" of Fort K played an important role during the Siege of Atlanta in August 1864. The gun reportedly took three days to drag into place and started firing August 9 in response to the Union's own bombardment. Ten Confederate and 11 Federal batteries took part in the engagement. Atlanta ultimately fell on September 2, 1864. (Library of Congress.)

After the war, Atlanta became a hive of activity and rebuilding. Richard Peters began developing his farm into a residential area called Peters Park. Stretching from North Avenue to Eighth Street on either side of Peachtree Street, the homes built in Peters Park were showplaces and hubs of social activities. In 1885, Peters donated four acres of Peters Park for the Georgia School of Technology, now known as Georgia Tech. (Library of Congress.)

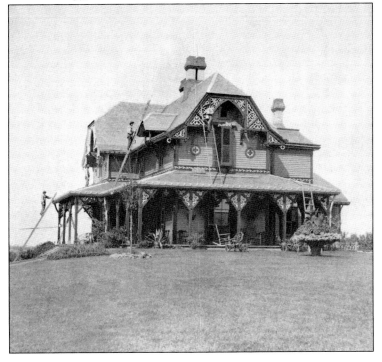

Entrepreneur Hannibal Kimball was manager of Peters Park, building his own home on the corner of Peachtree and Kimball Streets (now Ponce de Leon Avenue). Originally from Maine, Kimball had a huge impact on Atlanta, helping convince the legislature to name Atlanta the state capital. He helped the city grow, building railroads, canals, the elegant Kimball Hotel, and the Kimball Opera House. He was also director general of the 1881 International Cotton Exchange. (Atlanta History Center [AHC].)

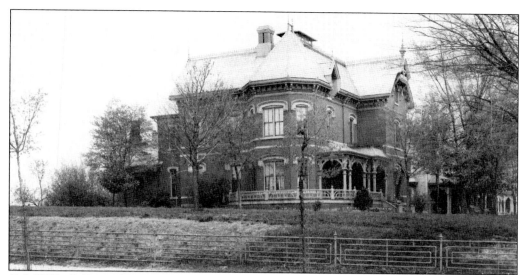

Col. Willis E. Ragan later purchased the land. A lover of flowers, he cultivated exquisite gardens around his home. Ragan made his fortune as a dry goods wholesaler. In 1908, poet William Rowe wrote of Ragan, "Great man of Georgia, So kindly and good, And here's to your worth, By all understood. A man of fine bearing, Of rare business skill, Deserves only the best. Will he get it? He will." (Library of Congress.)

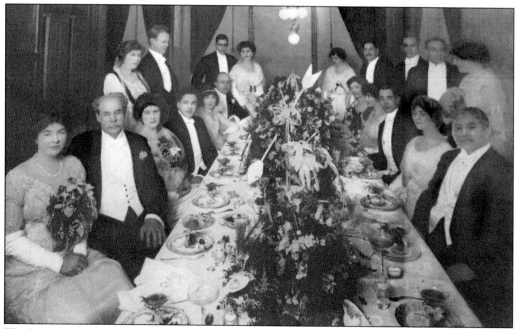

The Ragans loved to entertain. This dinner party was in honor of Sir Thomas Lipton, the founder of Lipton Tea. From left to right are (seated) Katherine Newman, Sir Thomas J. Lipton, Anne Orme, Ralph Ragan, Ethal Breckinridge, Joe Brown Connally, Leila Thornton, unidentified, Ed Alfriend, Marjorie King, and Willis Ragan; (standing) Esther Brown, Albert Thornton, Henry Newman, Passie Mae McCarty, Mattie Sue Percy, unidentified, James Ragan, Walter Colquitt, and Harriett Witham. (Atlanta History Center.)

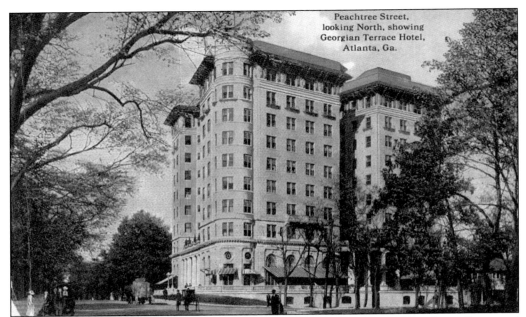

On October 2, 1911, the Georgian Terrace Hotel opened on the corner of Peachtree Street and Ponce de Leon Avenue as the first hotel to be built outside the downtown area. It had both residential and transient rooms available. The 10-story building was constructed in the Beaux Arts style so it would resemble a Parisian hotel. The cost of construction was $500,000, and it took more than a year to erect.

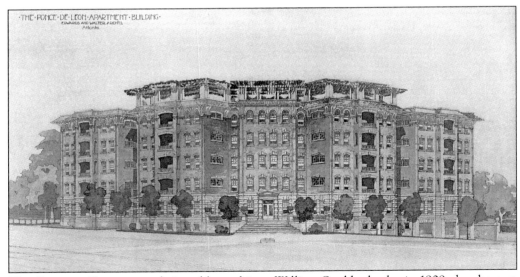

The Georgian Terrace was designed by architect William Stoddard, who in 1909 also drew up this design for an apartment building that would be built on the southeast corner of Peachtree Street, opposite the hotel. The original concept for the Ponce de Leon Apartments was for a much larger building. The project was scaled back considerably, and construction began after the Terrace opened. The Ponce de Leon Apartments opened in 1913. (AHC.)

The Ponce de Leon Apartments were advertised as "the South's most luxurious apartments." The building featured Atlanta's first penthouse. Its apartments ranged from small "bachelor suites" located on the two floors below the penthouse to spacious "housekeeping suites," which had up to 10 rooms each. There was also a dining room where residents could take three meals a day if they chose. (Fox Theatre.)

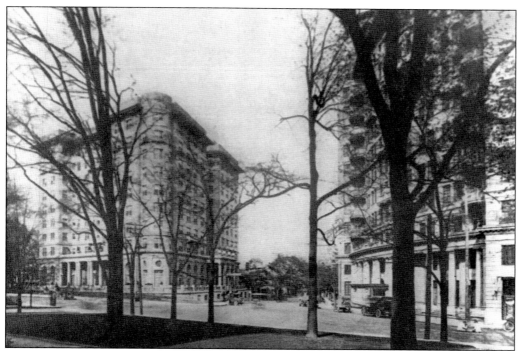

Building these two elegant structures in what had previously been a primarily residential area set the pace for more development at what was destined to become Atlanta's "most famous intersection." Popular shops lined the lower level of the apartment building. It was already considered a prime location because of its position on the streetcar trolley line. (AHC.)

This parade facing east from Terminal Station along Mitchell Street is from the 1914 convention of the Yaarab Temple of the Ancient Arabic Order of the Nobles of the Mystic Shrine. Known simply as the Shriners, the group had received its Atlanta charter in 1890 and had over 4,000 members at that time. In 1916, the group announced plans to build a mosque large enough to hold all of its members. (AHC.)

In 1922, the Shriners bought the property opposite the Georgian Terrace at the corner of Peachtree and Kimball Streets and began formalizing plans for their mosque. With the property valued at $225,000, they paid $89,000 and sold off what they didn't think they would need. In 1925, they held a competition to determine who would design their building. (Fox Theatre.)

The
MAGIC OF WORK
WELL DONE

It is believed the Atlanta chapter wanted their mosque to be Shrine headquarters for the entire Southeastern United States. They knew the venture would not be cheap. This is the cover of the brochure they created to promote the building fund they established. The funding campaign ran just two weeks between October 12 and October 26. It reached out to all 4,000 of the organization's members, who included Atlanta's most influential civic and business leaders. A group of 500 nobles residing throughout the Southeast were tasked with helping to recruit donors. Those who pledged a loan had two years in which to pay and were given a beneficial loan certificate issued by the temple, guaranteed by group insurance and a sinking fund. The Shriners raised moneys surpassing their goal of more than $1 million. Ground-breaking was held on November 23, 1925, although construction didn't start for two years. (Atlanta Masonic Library and Museum [AMLM].)

Architect Ollivier Vinour was among those competing to design the mosque. The 30-year-old Frenchman was relatively new to Atlanta and was working with architects P. Thornton Marye and Richard W. Alger. Marye and Alger were themselves Shriners, so they felt they knew what was needed but let Vinour take the lead. (Fox Theatre.)

This is just one of the intricate drawings Vinour submitted to convey how he envisioned the mosque to look when complete. He had taken his inspirations from a series of lithographs of the Alhambra in Spain, as well as from a series of postcards he had obtained from Sudan, Egypt, and the Middle East. (Fox Theatre.)

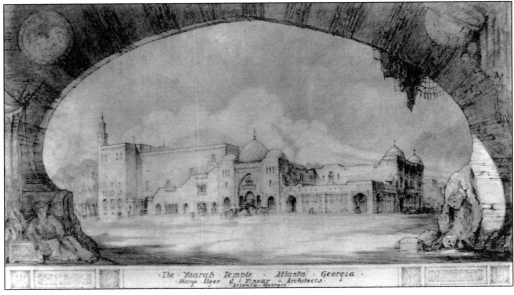

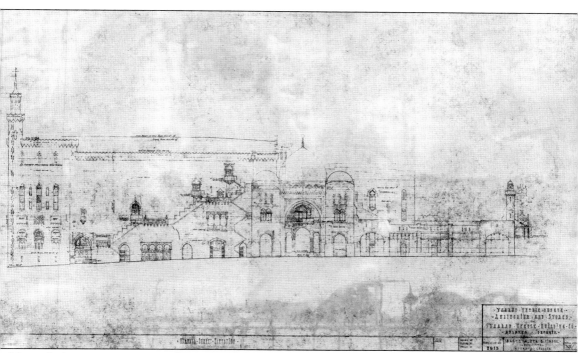

Vinour's designs were so over the top, with onion domes, minarets, and a Arab courtyard, that no other firm came close. Marye told Shriner potentate Thomas Law that the design would "out Baghdad Baghdad." Based on Vinour's designs, he was promoted to full partner in the firm Marye, Alger, and Vinour. When the Shriners awarded their firm the contract in 1927, Vinour oversaw the project, working directly with the contractors. The Shriners had held off on the design and building until their lot was fully paid for. They had estimated spending about $1 million to build their mosque. After seeing the design, they knew it would cost much more and began seeking alternate funding sources. They began negotiating with the Fox Film Corporation for long-term use of the auditorium as a movie theater. (Fox Theatre.)

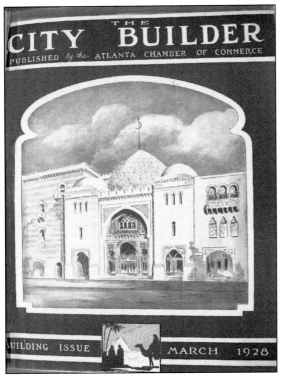

The deal was struck in January 1928 for a 21-year lease with the Fox Theatre Corporation. The Atlanta Chamber of Commerce's March 1928 *City Builder* magazine ran an article about the agreement, as well as the mosque's features. The cover depicted what was the planned main entrance that would face Kimball Street. Inside, the article featured Vinour's renderings of the new mosque, along with photographs of Fox founder William Fox (on the left) and Saul Rogers, who was vice president and general counsel of the corporation. The article referred to Atlanta as "the Gate City of the South" and described how the Yaarab Temple's nobility had spent 12 years planning and developing their mosque. The article commended their "wisdom, foresight and splendid business judgment" for making the temple possible and praised "this magnificent addition to Atlanta's civic beauty." The days the temple would require the auditorium for the Shriners' purposes were included in the lease. (Both, AMLM.)

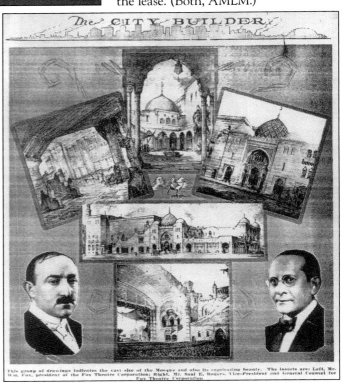

This group of drawings indicates the vast size of the Mosque and also its captivating beauty. The inserts are: Left, Mr. Wm. Fox, president of the Fox Theatre Corporation; Right, Mr. Saul E. Rogers, Vice-President and General Counsel for Fox Theatre Corporation.

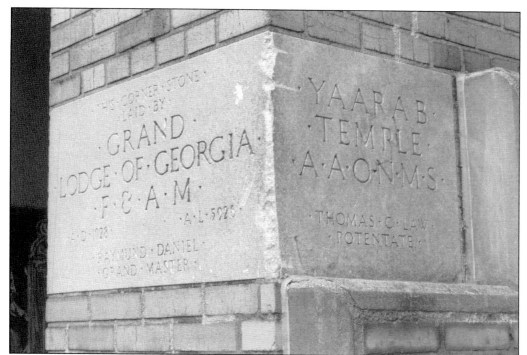

More than a dozen years in the making, anticipation of the new mosque was growing not just among the Shriners but also among Atlantans as a whole. The cornerstone was laid on June 14, 1928, amid much fanfare. Raymund Daniel, grand master of the Grand Lodge of Georgia for Free and Accepted Masons, officiated the ceremonies before a huge crowd of dignitaries and the curious. (Fox Theatre.)

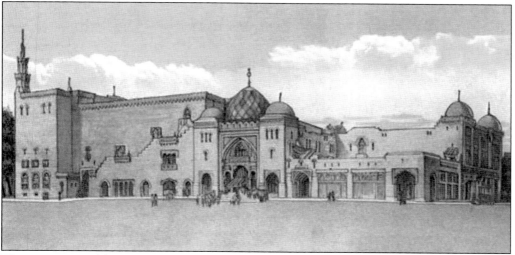

This is a postcard based on the renderings from Vinour's drawing. There are several distinct differences between this postcard and the building that was finally completed. Notice first that the entrance is on Kimball Street. The onion dome on top is a completely different pattern than what now exists. Also, on the right, there is a second story stretching to what became the Peachtree Street entrance. That portion was never built. (Janice McDonald.)

This program from the ceremony laid out the new mosque's highlights. The Yaarab wanted out-of-town members to use it as a base. Plans included bedrooms, lounges, a billiard parlor, a card room, and a library with space available for a restaurant. Each of the shrine's sub organizations had individual accommodations, equipment, and practice rooms. Since it was only to be used for official shrine gatherings a half-dozen times a year, it was designed so that sections could be rented out for other purposes and generate income. The stage for the 7,000-seat auditorium (later downsized) had a room where ceremonial equipment could be stored, making it easy to set up. The ballroom was to be the largest in Atlanta and could be completely cut off so it would not conflict with shrine activities. The entire building was fireproof. (AMLM.)

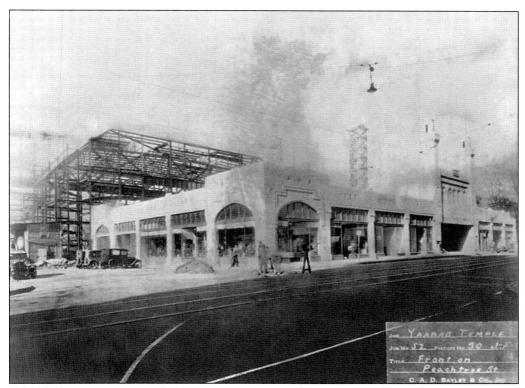

Published reports estimated that construction would cost $1.75 million, three-quarters of a million more than what had been raised. To offset costs, retail space was added to the exterior of the mosque along the Peachtree and Kimball Streets. Those stores were essentially phase one of construction, and as seen in the photograph, some of the shops were already open well before the rest of the project was completed. (Fox Theatre.)

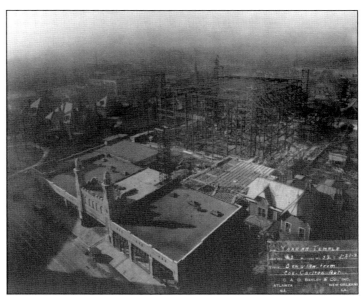

The storefront sections were designed so they could later be removed, and a taller structure could be added. The Fox Corporation was contributing nothing towards building expenses, but the lease agreement with Fox was worth an estimated $3 million. The Shriners used the deal as leverage in seeking a construction loan from the Trust Company Bank of Atlanta. They succeeded in getting what they felt would be enough to complete the project. (Fox Theatre.)

RYBERT-CUNDELL PRINTING CO.
311 Edgewood Avenue, S. E.
SERVICE UNEXCELLED · Ivy 3317 · PRICES SATISFACTORY

Plans for the mosque had to undergo several modifications for financial and practical considerations. Fox's owner, William Fox, was allowed his own input. Probably the most notable change attributed to him was the entrance. Originally, the main entrance was on Kimball Street, but Fox felt that Peachtree Street was more traveled. Plans were redrawn to create a 140-foot arcade entrance on Peachtree. (AMLM.)

The steel skeleton of the auditorium is clearly seen in this 1928 photograph. The construction company of record was C.A.D. Bayley Company, with Joseph Shaw listed as the construction specialist. While construction was under way, Kimball Street, which was an extension of Ponce de Leon Avenue, was renamed. (Fox Theatre.)

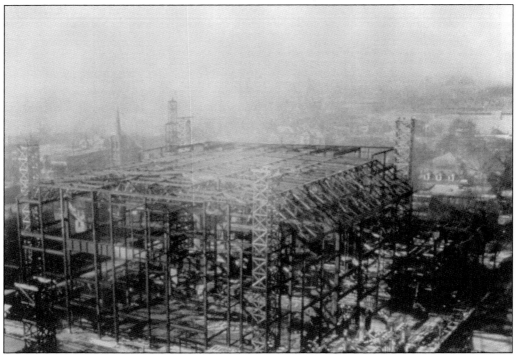

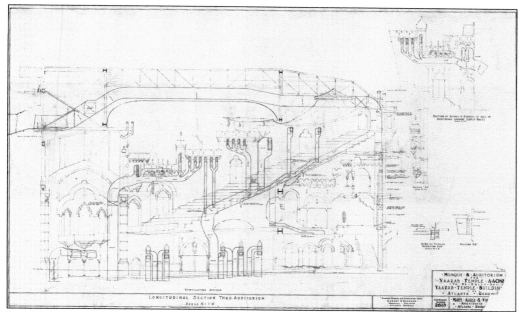

In addition to its unique visual design, the new building also boasted state-of-the-art systems. This architectural drawing shows the duct work for the temple's heating and cooling systems and where it is hidden in the architecture. While the systems have been upgraded over the decades, the duct work remains essentially unchanged. The mosque was air-conditioned five years before the White House. (Fox Theatre.)

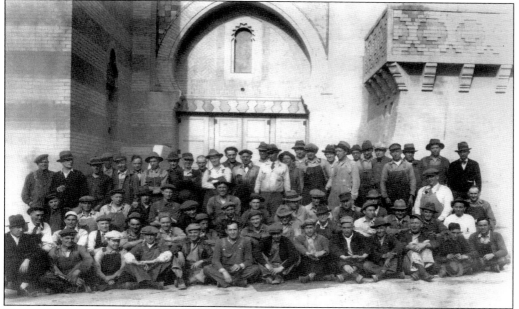

Electrical wiring for the mosque was completed using electricians who formed the Atlanta Electrical Contractors Association (AECA) while still working on the building. The AECA boasts that the project was among the group's first. On the third row, fifth from the left, is Robert Henry Miller, whose granddaughter Kathy Spinks held onto this photograph. (Kathy Spinks.)

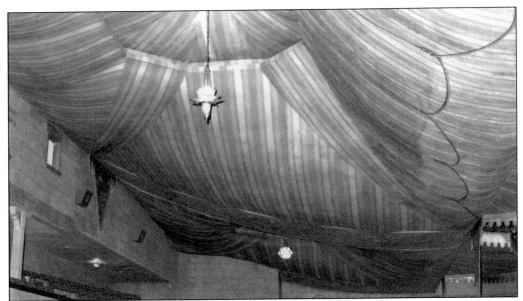

What looks to be a billowing tent canopy above the balcony serves two purposes: first, it hides the openings for the auditorium's air-conditioning, and secondly, it is there for acoustics, deflecting sound. The canopy is made of plaster but has been painted to look like cloth. The design above the tent and throughout the auditorium was modeled to give the illusion of a night sky. (Hal Doby.)

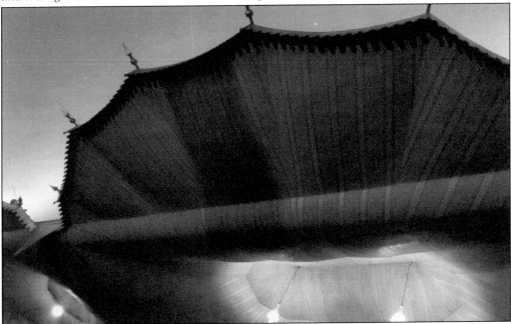

The deep-blue ceiling color was originally created by mixing buttermilk, glue, and ultramarine pigment. A long standing myth is that the 96 twinkling stars were grouped to look like the night sky of Saudi Arabia. Eleven-watt bulbs shine through three-inch crystals to make them "twinkle." To further wow the audience, the sky gave the illusion of the sun setting before a performance and then rising after it was over. (Janice McDonald.)

Images projected for sing-alongs and for backdrops during performances were created with a machine called a brenograph. First manufactured in 1928, the Fox's Brankert F-7 Master Brenograph was the largest and most advanced of the brenograph machines. The Fox continued to use it for special-event sing-alongs until 2010. (Fox Theatre.)

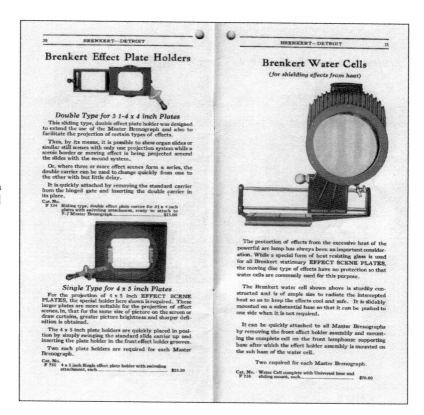

The auditorium's stage is divided into three sections, each with two lifts. Each one is capable of lowering 40 feet into the basement or rising four feet above the footlight. The two largest can transport an entire chorus. Spanning 125 feet across from wall to wall, the stage was and is one of the widest ever built; however, at just 35 feet, it is very shallow. (Fox Theatre.)

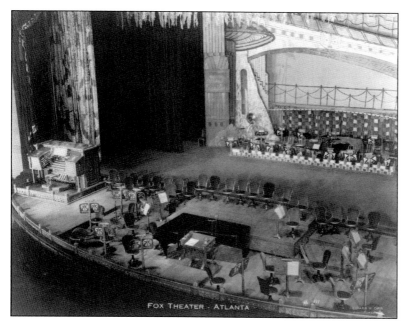

The entire massive structure was built with a complete basement that still houses support departments such as electrical and workshops. The building is heated by two steam boilers that were fired by coal. The coal was delivered to the basement through a chute via a door located on the north side of the theater where the central receiving alley is today. One of the boilers was converted to gas in the 1970s and the other in the 1990s. They still heat the Fox. (Janice McDonald.)

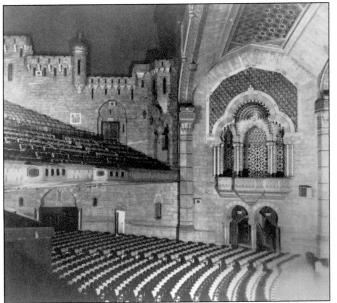

Much of the interior was an illusion created using plaster and paint. The faux stone walls of the auditorium are formed plaster, as are the metal-looking grates behind the decorative balconies on either side of the stage. (The grates hide the five chambers that house the pipes and instruments of the celebrated Möller theater organ.) The wooden beams in the ceiling of the mezzanine are also not wood but plaster. (Fox Theatre.)

The balcony, one of the largest in the world, is a feat of engineering. Seating 1,850, it can expand up to three millimeters when fully occupied. Lead carpenter Bob Davis later considered it one of his greatest achievements. When the completed balcony was measured, it was within a fraction of an inch of what plans had called for. (Fox Theatre.)

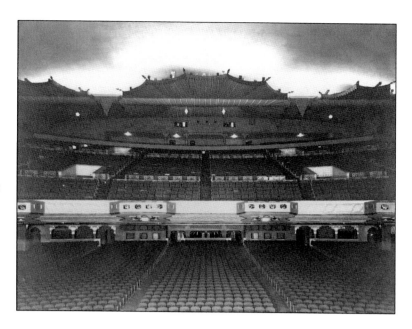

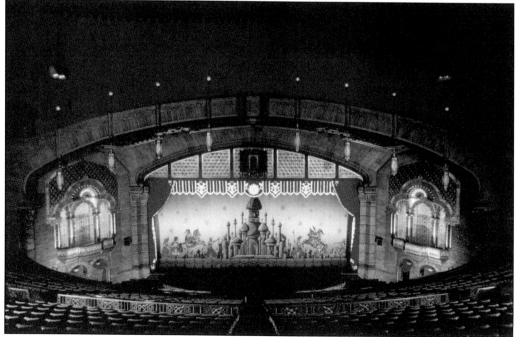

The Fox has several curtains, the most spectacular of which is known as the Jewel Drop. Hand painted for the Shriners with an elaborate Arabian Nights theme, it has sequins and beads hand sewn on to it so that it sparkles as theater lights hit it. The curtain was bought the same year the mosque opened for a cost of $30,000. It is still in use. (Fox Theatre.)

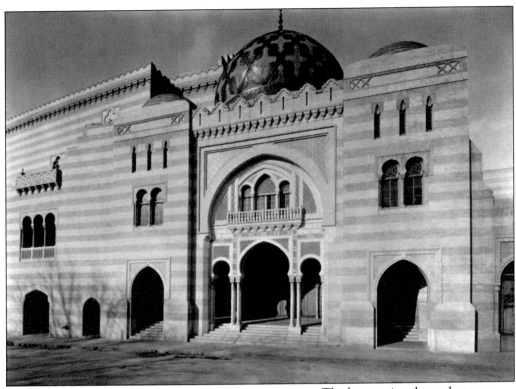

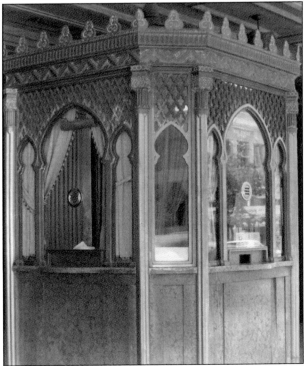

The large onion dome that tops what was originally supposed to be the mosque's main entrance is made of two types of brass, thus giving it a two-toned appearance. Having two metals meant it would oxidize in different ways, so the designs on the dome would remain distinguishable over the years. At the dome's base is an inscription in Arabic. While the letters are authentic, they have no meaning. (Fox Theatre.)

Movie and theater customers of that time bought their tickets from kiosks. The kiosk chosen to sit at the entrance of the Fox arcade had to fit the building's elaborate motif. The intricately designed brass booth was made specifically for the theater by a Midwestern company. While a larger, more modern ticket office was later added, the historical kiosk is still used on some occasions and for will call. (Fox Theatre.)

The doors in the arcade were originally fitted with stained glass. Given the amount of use and pushing the doors received, it was an impractical design, and the glass was easily broken. It is not clear just when, but at some point, the stained glass was replaced by plain sheet glass. (Fox Theatre.)

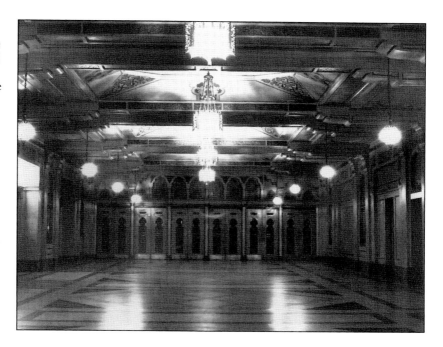

Many of the decorative light fixtures were produced by the Sterling Bronze Company and handcrafted and hand painted. The lighting atmosphere was considered very important, so much so that fixtures were wired specifically to accommodate different wattage. (Janice McDonald.)

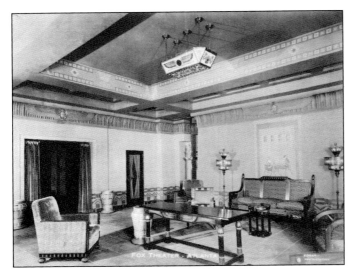

William Fox's wife, Eve, was credited with decorating public places, although there is no evidence she ever personally came to visit. She listed her occupation as "Interior Decorator of Theaters" on the 1930 census. Most of the Egyptian- and Moorish-themed furnishings were created by Chicago firm Ketcham & Rothschild, which manufactured handcrafted furniture from 1870 to 1930. The firm was known for intricate carvings and guild work. (Fox Theatre.)

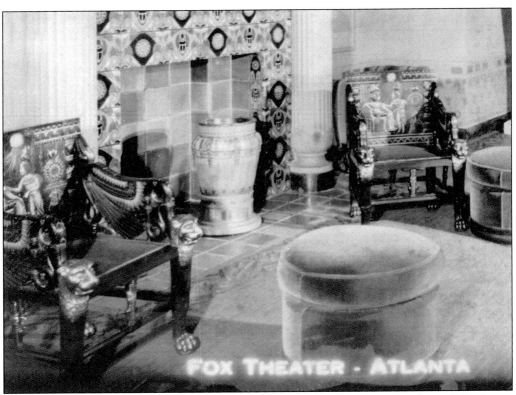

The Egyptian throne chairs found in the ladies lounge on the mezzanine are replicas of the throne chair of King Tutankhamen. King Tut's tomb had been discovered in November 1922, and many of the Fox's decorations are drawn from things from the tomb. The relief on the back of the chair depicts the Sun King and his wife receiving a blessing from the Sun God. (Fox Theatre.)

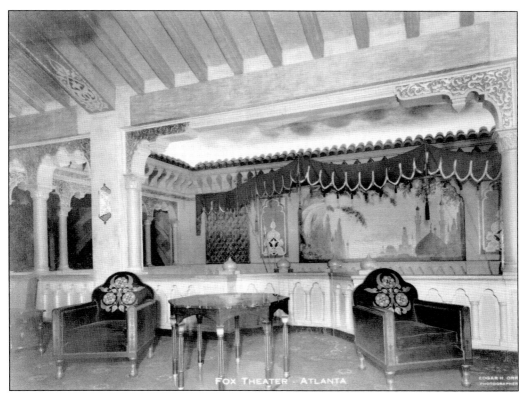

The mezzanine level continued the temple's Arab courtyard theme and included a balcony with a mural, giving the illusion of looking off at a Moorish city in the distance. The fabric canopy is indeed made of cloth, unlike the painted concrete canopy located above the balcony in the main auditorium. The furniture in the area was hand carved with mohair velvet cushions. (Fox Theatre.)

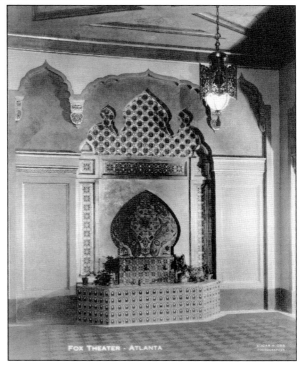

Traditional Islamic mosques have fountains at their entrances for worshippers to purify themselves, so of course, the shrine mosque had fountains to keep up the Middle Eastern illusion. In addition to this one near the entrance, a fountain also was situated at the entrance to the Grand Salon. The ornate tiles were produced by the Flint Faience & Tile Company, a subsidiary of the makers of Champion Spark Plugs. (Fox Theatre.)

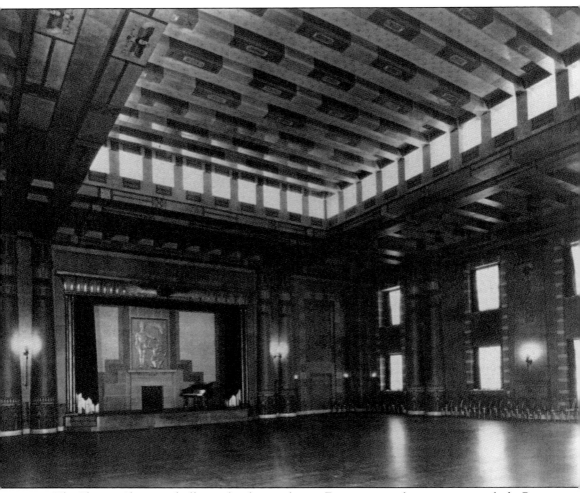

The Shriners' banquet hall was also designed in an Egyptian motif to mimic a temple for Ramses II. Now known as the Egyptian Ballroom, the area was accessed via stairs through a separate entrance off the arcade. The picture of Ramses subduing an enemy over the fireplace is made of plaster and painted to look metallic. The fireplace itself is just for show and cannot be used. Above the stage are the outstretched wings of Osiris, the god of the underworld, while on the balcony facing the stage is a scarab or dung beetle (not shown). While much has been made of messages written on the walls, the hieroglyphics that decorate the ceiling and walls, while authentic, tell no story. The floors of the hall were made of hard rock maple. (Fox Theatre.)

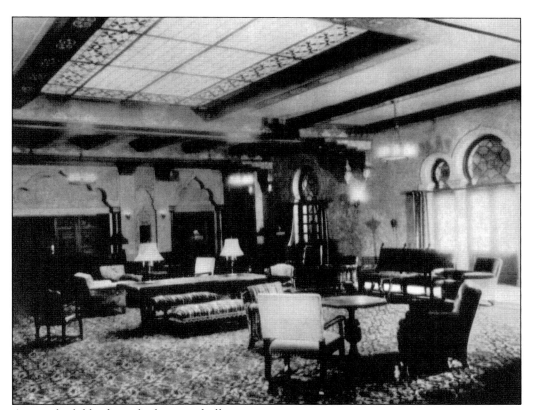

Across the lobby from the banquet hall was a room designed specifically for the Shriners to be able to relax and socialize in. Called the Grand Salon, it was opulently furnished with a stunning stained-glass skylight. What appear to be large, exposed wooden beams are simply plaster with a wood-graining paint technique called *faux bois* (French for "false wood"). (Fox Theatre.)

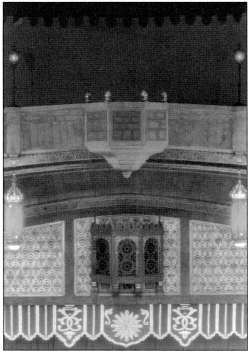

The proscenium, high above the stage, was designed to look like a bridge and hides a catwalk to access lights. The balcony in its center is there simply for decoration, but below it is a window-like structure that housed the Movietone speaker. It was installed towards the end of construction when it became apparent that talkies would be replacing the silent movies. The speakers continued to be used until the 1980s. (Fox Theatre.)

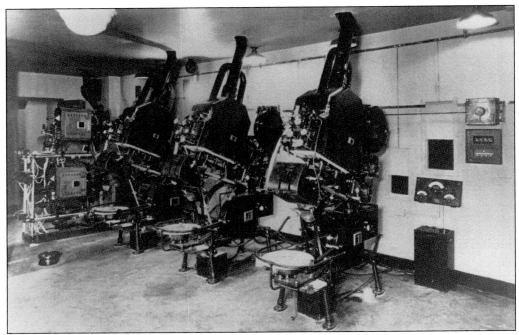

During a time when most movie houses had two projectors, the Fox had three. The third was a backup and considered a real luxury. A movie was generally long enough that it came on more than one reel. Both machines would be loaded, and the reels carried marks that would flash on screen to let the projectionist know when to start the second projector so the movie could continue uninterrupted. (Fox Theatre.)

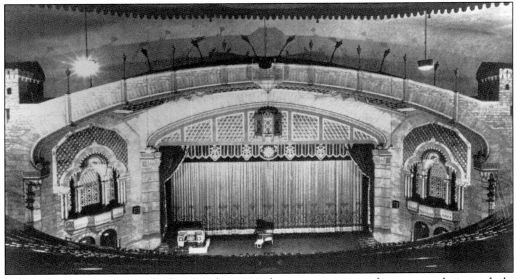

When the stock market crashed in October 1929, the mosque was too close to completion to halt. Construction was finally completed in November, although the crash had affected some suppliers. Notably, the auditorium's chandeliers' lights were never delivered. Electricians bought metal wash buckets and cut holes in them to insert lights. One of the buckets is visible in this photograph. These lights remained in use until the Fox's restoration in the 1980s. (Fox Theatre.)

Two

THE FOX

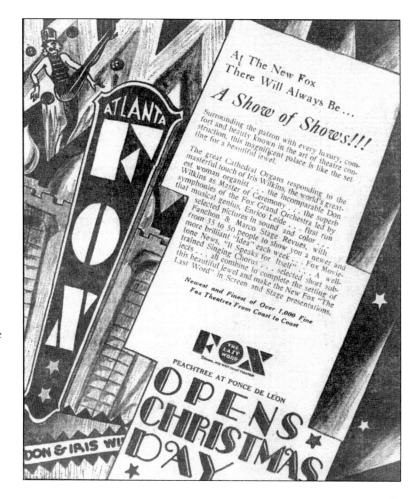

The buildup to the Christmas Day grand opening of Fox Theatre at the Yaarab Shrine Mosque was palpable. With the final program set, newspapers carried advertisements for weeks prior to the opening to stoke the anticipation. There were feature articles about all aspects of the mosque, which had been so long in the making that people would come and simply watch it being built. (Fox Theatre.)

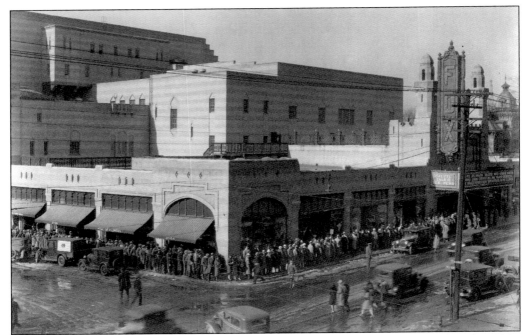

Atlanta had been experiencing frigid temperatures, so when Christmas Day dawned in the 1920s, there was relief for the thousands who stood in line to be the first to experience the Fox Theatre. There were two shows that day: a matinee at 1:15 p.m. in the afternoon, followed by the grand opening premier gala at 8:30 that evening. (Fox Theatre.)

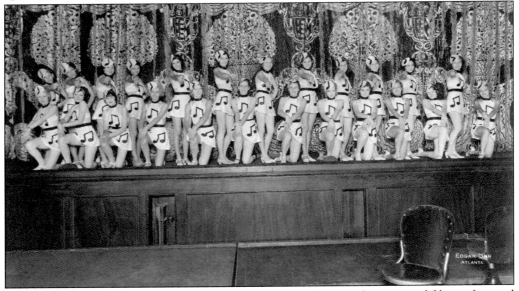

The lineup for the show was impressive. A combination of music, dancing, and film, it featured a dancing chorus known as Fanchon and Marco's Sunkist Beauties. This photograph is of a later Fanchon and Marco production, *The Merrie Maids of Melody*. The Fox opening performance of *Beach Nights* included a 12-girl dance chorus of Atlanta natives. The *Atlanta Constitution* called the troupe "two carloads of feminine pulchritude." (Fox Theatre.)

The entire show began with the a prelude on the mighty Möller pipe organ, played by Iris Vining Wilkins. Orchestra leader Enrico Leide raised his baton to what was described as "a triumphal return to the theatrical life of the city," leading the Fox Grand Orchestra in "This Shrine of Beauty," a variation of *Pomp and Circumstance*. The audience was treated to Walt Disney's first talking cartoon, *Steamboat Willie*, starring Mickey Mouse. In addition to the Fox Movietone newsreel, there were performances by a Japanese acrobatic trio called the Kitaros, several comedians, Jean & Jeanette "The Singing Sisters," and finally, the movie feature *Salute*. A John Ford and David Butler–produced film, it starred George O'Brien, Helen Chandler, William Janney, and Stepin Fetchit. (AHC.)

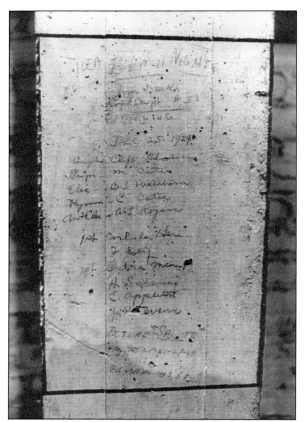

The rundown for Fanchon and Marco's portion of the first show is seen scribbled in the concrete backstage. Fanchon and Marco were an internationally known brother-and-sister musical and dancing Vaudeville act who became known for their own stage productions. Better known on the West Coast, they referred to any production as an "idea." They produced shows at the Fox for almost two years. (Fox Theatre.)

The *Atlanta Journal* referred to the Fox as "a bewildering spectacle of sheer opulent magnificence." The curious and those seeking to be entertained continued to come and sit in the audience. The building itself was a curiosity for many because everything about it was new and unique to Atlanta. The Fox proved to be just the distraction many needed to escape the reality of the Great Depression, if only for a few hours. (Fox Theatre.)

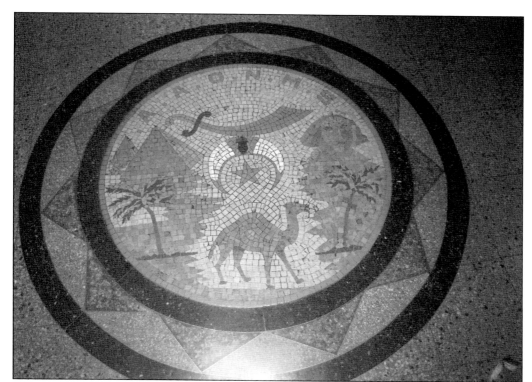

This seal in the floor of the stairwell leading to what is now the Egyptian Ballroom is a reminder that the building was still considered a Shrine mosque, despite its movie and theatrical audiences. On New Year's Day, 1930, the Yaarab Temple of the Ancient Arabic Order of the Nobles of the Mystic Shrine dedicated its temple in secrecy. (Janice McDonald.)

As patrons entered the theater, their tickets were placed in this ticket shredder. The wheel on the side would be turned to do the shredding. As with many of parts of the Fox's gilded-looking interior, the machine's appearance is deceptive. It is not gold but aluminum that had been painted with gold-colored paint. (AHC.)

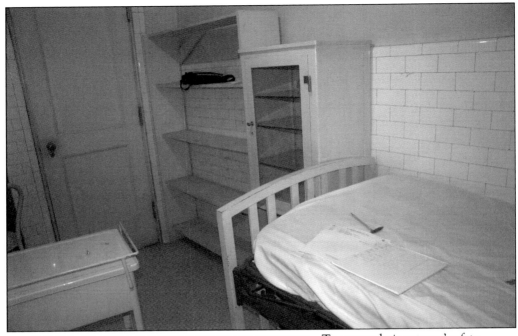

To assure their patrons' safety, there was also an onsite hospital. Located on the lower level near the entrance to the Ladies Lounge, the Hospital Room was staffed by a nurse whenever there was a performance or an event. The clinic is equipped with a hospital bed and enough medical supplies to handle everything from minor injuries to broken bones. (Fox Theatre.)

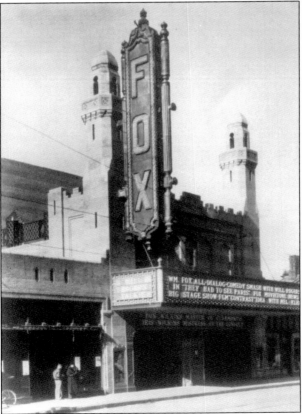

William Fox's involvement in his namesake theater was short lived. Mired in debt from problems that started even before the stock market crash, he was ousted from the Fox Films Corporation, and by August, Loew's, Inc., began managing the theater. The theater company already had the Loew's Grand downtown, but when it took over the Fox, it made it the flagship Loew's theater in Atlanta, relegating the Grand to second runs. (Fox Theatre.)

Dickinson Florists was among the first tenants to rent out space in the retail areas on the theater's exterior. The nine slots facing Ponce de Leon Avenue and Peachtree Streets drew a lot of pedestrian traffic and proved popular. They were rented long before the theater had its opening. Dickinson occupied the store on the corner of Ponce de Leon and Peachtree. (Fox Theatre.)

Within a year of its opening, the fate of the entire operation was in question. Hit hard by the Great Depression, the Yaarab Temple's membership was decimated by those unable to pay their dues. It fell badly behind on its mortgage. In November 1931, Trust Company of Georgia began foreclosure proceedings against it. (Fox Theatre.)

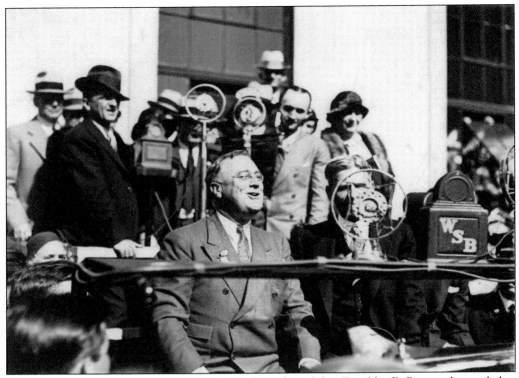

On May 22, 1932, New York governor and presidential candidate Franklin D. Roosevelt traveled to Atlanta to receive an honorary doctorate from Oglethorpe University at its graduation ceremonies at the Fox. In his often-quoted speech, he lauded the importance of "bold, persistent experimentation," saying, "If it fails, admit it frankly and try another. But above all, try something." In November, FDR won the presidency. (AHC.)

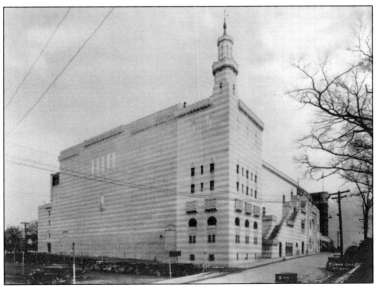

The next two years were filled with legal and financial turmoil for the Fox. The Shriners declared bankruptcy in June 1932, and the Fox was closed. It reopened less than two months later under new management. Foreclosed on in November, it was sold at auction for just $75,000 to Theater Holding Company, a corporation formed by several of the former shrine bond holders.

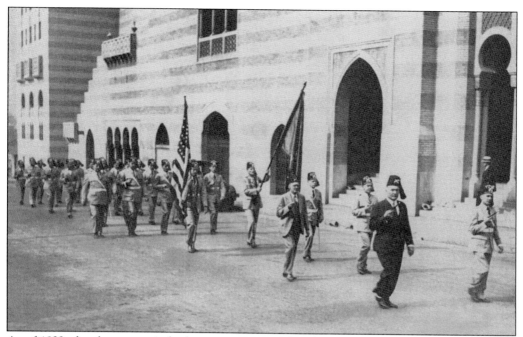

As of 1933, the theater again had paying tenants. The Shriners obtained a lease to utilize the mosque portion of the building and moved back into their offices. Through a series of leases over the next decade, they continued to occupy part of the building until they built a new mosque and moved in 1949. (AMLM.)

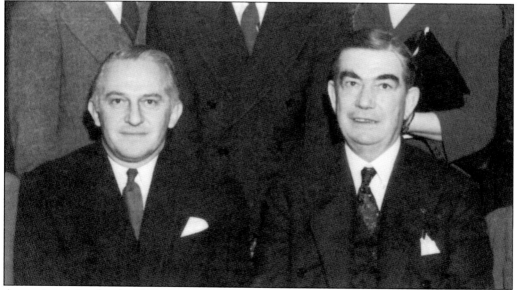

A turning point for the theater occurred in 1934, when Arthur Lucas (right) and William K. Jenkins took over the lease of the Fox. The men had a history running community theaters, and this was their first movie theater. While their tenure was successful, the ownership of the Fox remained in flux, with the ownership ultimately settling with a group called Mosque, Inc. (Fox Theatre.)

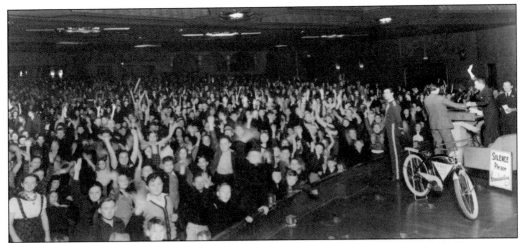

Lucas and Jenkins's experience as promoters proved to be what the Fox needed. Soon it was hosting a never-ending variety of shows, including this one for Rogers Stores. Rogers Stores was the largest grocery store chain in Atlanta in the 1930s and sponsored *The Kid's Quiz* live radio show at the Fox. The winner received a new bicycle. (Fox Theatre.)

Concessions were not part of the early Fox offerings; that would come much later. Originally, patrons had to buy food or drinks outside and consume them there. A small concession stand was added in the mid-1930s. Located on the right as patrons entered the lobby, it was against the same wall that now provides access to the Spanish Room. (Fox Theatre.)

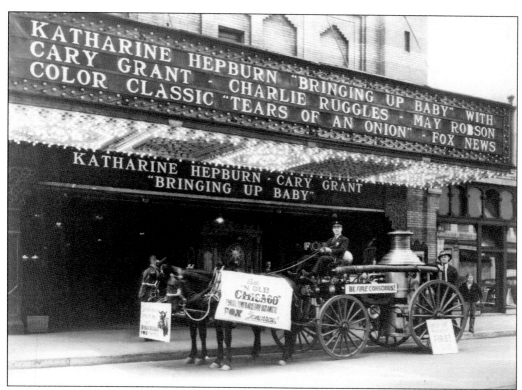

Each new movie was celebrated with an elaborate publicity campaign to garner public interest and draw in moviegoers. *The Toast of New York* of 1937 was a semibiographical movie about 18th-century robber barons Edward S. Stokes and James Fisk. Its promotions included the modeling and display of one of the dresses worn by star Francis Farmer. In the photograph above, *Bringing up Baby* was showing at the Fox, but the campaign had already started for the next movie. An old-fashioned fire engine was used to promote the upcoming film *In Old Chicago*. Starring Tyrone Powers, Alice Faye, and Don Ameche, the movie was about the occurrences prior to the Great Chicago Fire of 1871. (Both, Fox Theatre.)

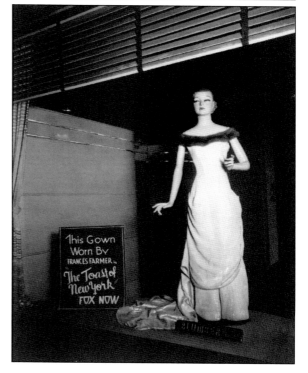

Opera diva Rosa Ponselle takes a bow after performing with pianist Stuart Rose at the Fox. This October 14, 1937, appearance was one of her final performances. Considered one of the 20th century's greatest sopranos, she sang mostly with the New York Metropolitan Opera. Ponselle sang in her last opera in April 1937 and eventually slipped into retirement. (Georgia State University [GSU].)

Being an usher at the Fox was a source of pride for those who held the position. Appearances were extremely important. Each day as they came into work, the ushers would line up in military fashion for inspection. Attention was paid to every detail, down to the way they combed their hair, how their shoes were polished, and even the condition of their fingernails. (Fox Theatre.)

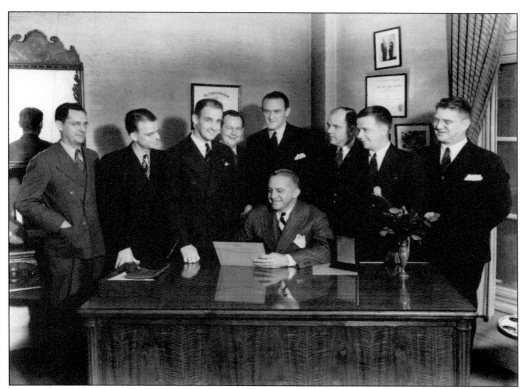

In 1939, Lucas and Jenkins formed the Georgia Theater Company (GTC) to manage other theaters as well. GTC also became the official operators of the Fox. Pictured here are many of the people who ran the Fox over the next decade. From left to right, they are Earl Holden, Willis J. Davis, Chappy Reinhold (accountant), Moon Corker, E.E. Whitaker, Jenkins (seated), Tommy Read (manager), E.B. Whitman, and Billy Pratt. (Fox Theatre.)

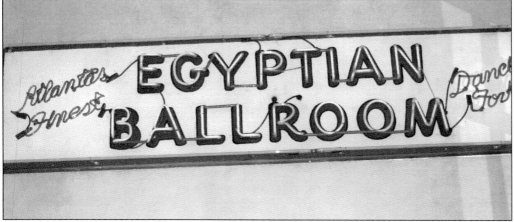

Under GTC, the Banquet Hall was renamed the Egyptian Ballroom, and its name was written in neon for customers to spot easily. The company began renting it out for functions other than those of the Shriners. This was the beginning of the Fox's long history as a popular venue for social events, banquets, and dances. The Shriners were forced to move their offices downstairs while GTC took over the Grand Salon to use as its office. (Hal Doby.)

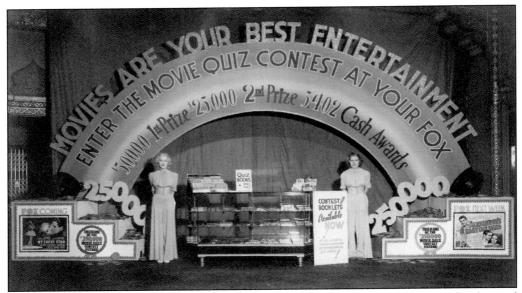

In an effort to encourage more people to attend the movies, the motion picture studios banned together in 1938 to create the National Movie Quiz. Each city had designated movies that were part of the quiz and booklets with questions associated with those movies. Newspapers carried advertisements so that patrons would know which movies they should see if they were following the quiz. To be able to answer the questions, the theory was that one had to actually see the movies. Over 5,000 prizes were available for giveaway, with the top prize being $50,000 and second prize being $25,000. The Fox Theatre was among the theaters in Atlanta that were part of the contest. An estimated 18,000 movie theaters across the United States participated in the promotion. (Both, Fox Theatre.)

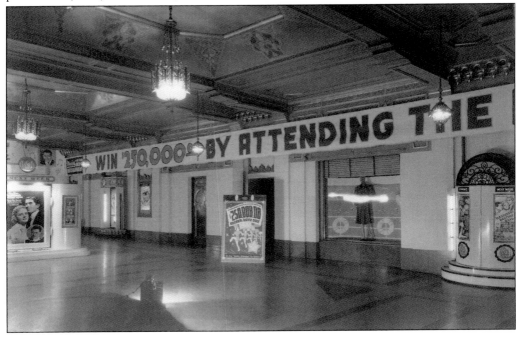

These three photographs from 1939 show the changing neighborhood around the Fox. They were taken from the roof of the Cox Carlton Hotel to the north of the Georgian Terrace. The top photograph includes part of the Ponce de Leon Apartments with downtown in the distance. The house that dominates the second image was the residence of Frank E. Block. He was president of the Frank E. Block Company, which made candy and crackers. The final picture shows a rare look at the patio on the roof of the arcade outside the Grand Salon. The movie screening was an action-packed western called *Union Pacific* staring Barbara Stanwyck and Joel McCrea. (All, Fox Theatre.)

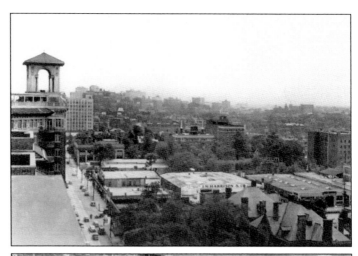

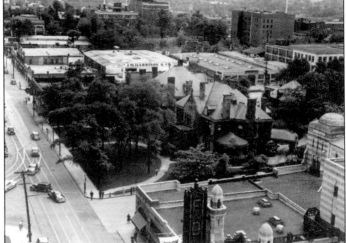

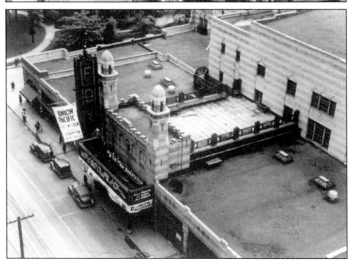

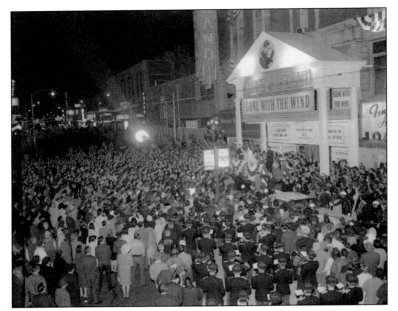

A common misconception is that the Fox was the site of the 1939 world premier of *Gone with the Wind*. The much-anticipated adaptation of Atlanta author Margaret Mitchell's classic novel was actually held at the Loew's Grand Theatre in the heart of Atlanta's downtown theater district. The Grand was owned by MGM, which coproduced and cofinanced the movie. (AHC.)

The Fox was not entirely left out of the three-day celebration. The stars of the movie stayed in the Georgian Terrace, directly across the street. This photograph shows, from left to right, Olivia De Havilland (Melanie Hamilton), Vivian Lee (Scarlett O'Hara), and her husband, Lawrence Olivier. In 1989, the Fox was chosen for the site of the 50th-anniversary "re-premiere." (AHC.)

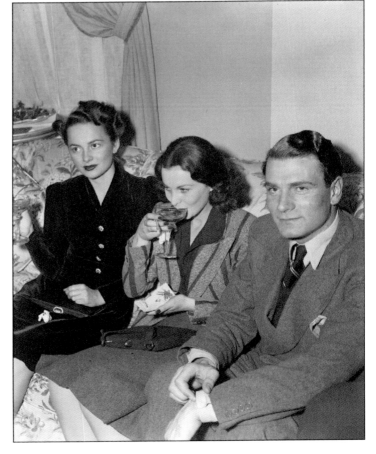

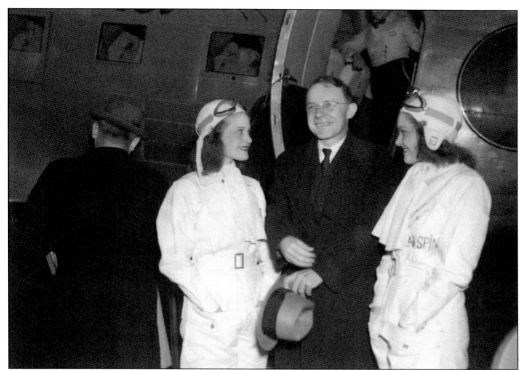

The Fox was noted for being able to score its own fair share of premieres for films starring some of Hollywood's biggest names. When Twentieth Century Fox's 1939 movie *Tail Spin* made its premiere, Atlanta's mayor, William Hartsfield, got in on the festivities. Amid much fanfare, the mayor greeted some of the stars and movie officials upon their arrival at the Atlanta airport. (Fox Theatre.)

The 140-foot-long arcade leading to the entrance of the Fox was utilized to help promote movies that were showing or others that were coming soon. Windows were decorated with cross promotions sponsored by local businesses. In other cases, elaborate portable displays were erected in the walkway within the arcade. (Fox Theatre.)

Female employees of the Fox also had an image to maintain, taking pride in their uniforms as much as the men. The women in this picture are also sporting broaches on their ascots bearing the initials "LJ" for Lucas and Jenkins. (Fox Theatre.)

The comedy team of Bud Abbott and Lou Costello had only been working together six years when they premiered their movie *In the Navy* at the Fox on May 28, 1941. From left to right are Sam George (manager of the Paramount Theater), Costello, Abbott, and Judson Moses (public relations manager). (Fox Theatre.)

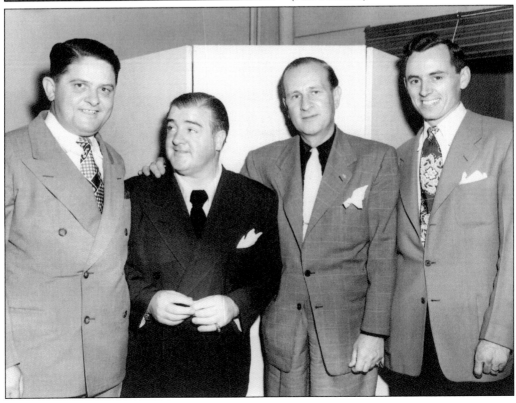

As with any premiere, the publicity included an advertising campaign as well as a series of promotional stunts to help build the audience's anticipation. The movie, which also starred Dick Powell and the Andrews Sisters, was about a popular singer who abandons his career and joins the Navy. At that time, much of the world was at war, and most of Europe was under the influence of Nazi Germany. (Fox Theatre.)

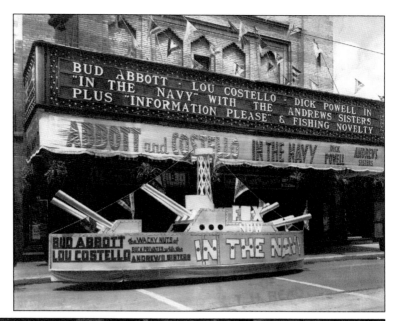

When the movie *Parachute Battalion* premiered on August 14, 1941, five hundred members of Fort Benning's 501st Parachute Battalion were on hand to take in the film. Ten buses were needed to bring in the servicemen from just outside of Columbus, Georgia, almost two hours away. Notice the small black sign visible on the wall above the bus on the left side of the photograph designating the "Colored Entrance." (GSU.)

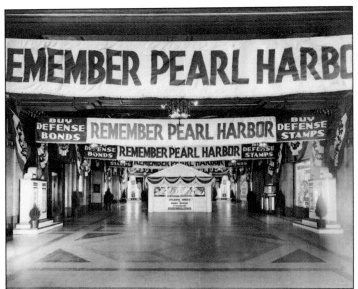

When Japan bombed Pearl Harbor on December 7, 1941, the United States officially entered World War II. The War Finance Committee began an intense advertising campaign to raise money through the sale of bonds. Theatergoers could a sign up to purchase bonds in the atrium of the Fox. More that 85 million Americans purchased bonds, totaling approximately $185.7 billion in sales. (Fox Theatre.)

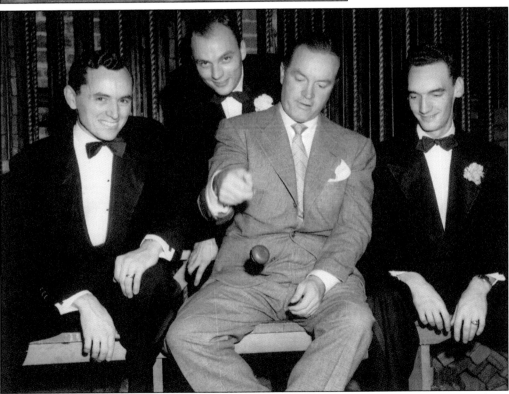

Despite World War II, the phrase "the show must go on" rang true. Bob Hope was among those who came to the Fox. Former usher Joe Williams later recounted the performance, saying Hope told the crowd, "I hope you people have brought your lunch or a snack or something because we're liable to go on all night." After the show, he posed with Williams and some friends. From left to right are Judson Moses, Williams, Hope, and Roscoe Womack. (Joe Williams.)

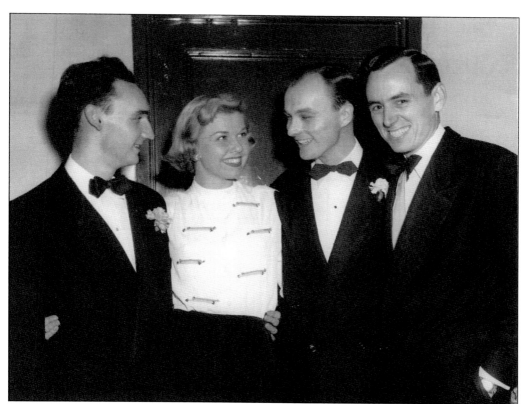

Before she began acting in movies, singer Doris Day was performing with the Les Brown Band. In 1944, she and the band took the stage at the Fox. They also reportedly performed at Georgia Tech's senior prom. Day is pictured here with, from left to right, theater treasurer Roscoe Womack, Joe Williams, and Judson Moses. (Joe Williams.)

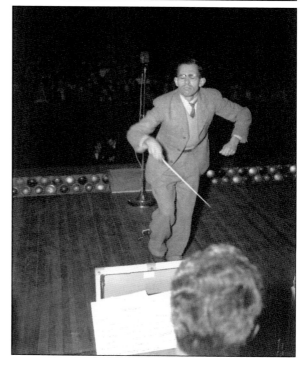

Composer and orchestra leader Sammy Kaye was among the most popular big band leaders of the era and played the Fox both during the war and after. Nicknamed "Swing and Sway," Sammy Kaye was known for getting his audience to participate, often pulling someone up on stage to conduct his orchestra for him. (GSU.)

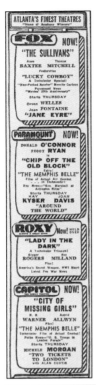

The advertisement in the *Atlanta Constitution* from 1944 shows a typical lineup of what was playing across town. Most of the movies have a war theme. Playing at the Fox is *The Sullivans*, which was later rereleased as *The Fighting Sullivans*. The biographical tale follows five Irish American brothers who fought and ultimately died during the naval battle at Guadalcanal. (*Atlanta Journal Constitution*.)

Musical entertainment was as important as movies, and in addition to paid performances, the Fox and the City of Atlanta sponsored free afternoon pops concerts that drew in thousands. Music was conducted by Albert Coleman, a Frenchman who came to Atlanta as a musical director for WSB Radio. He formed the Atlanta Pops in 1945 and led it for 55 years. Coleman was also a popular symphony conductor, traveling throughout the United States. (Fox Theatre.)

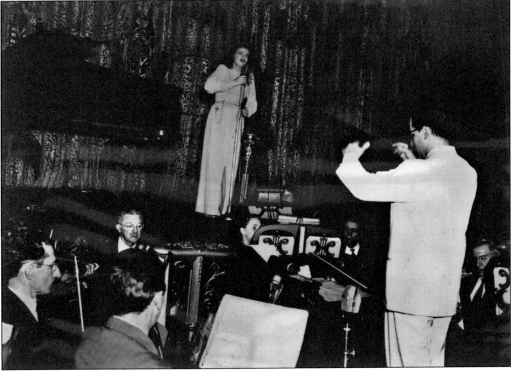

With World War II ending in 1945, people took to the theater in droves to be entertained. Hollywood recorded 1946 as a banner year. On November 12, the Fox hosted the world premiere of Walt Disney and RKO's *Song of the South*. Based on Georgia folklorist Joel Chandler Harris's Uncle Remus works, the musical, which combined live action and animation, was heralded far and wide as Walt Disney's greatest accomplishment yet. (GSU.)

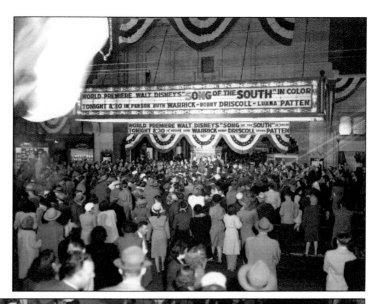

Walt Disney himself took part in the festivities, but lead actor Bobby Driscoll could not because of segregation. While many praised the movie's technological advances, the NAACP was among those criticizing it for perpetuating a "dangerously glorified picture of slavery." Despite two Academy Awards, it is one of the few Disney films that have not been rereleased to the video market in the United States. (GSU.)

The end of the war also meant a growth in the popularity of the automobile. In the summer of 1946, the Fox opened up a parking lot on the north side of the building that served a dual purpose so novel for that time that it was reported on in newspapers as far away as Canada. (GSU.)

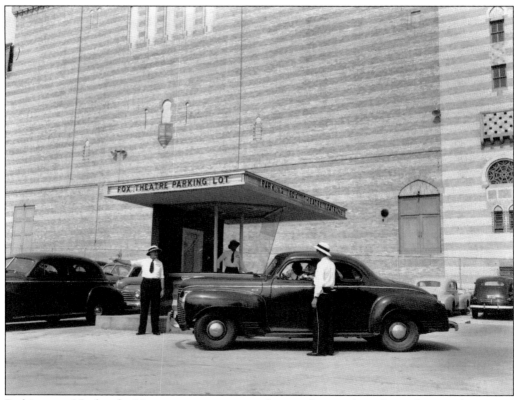

Parking was 25¢, but for 10¢ more, patrons got parking and a round-trip bus ticket to a downtown destination. The lot was opened for commuters during the day but reserved for movie patrons after 6:00 p.m. and all day on Sunday. The bus service was operated by Georgia Power, while the Fox managed the actual lot. The grand opening was almost as celebrated as any premiere. (GSU.)

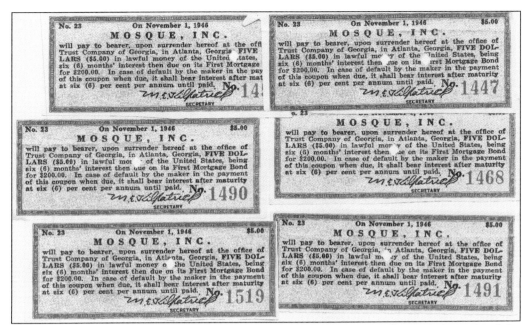

In 1946, Mosque, Inc., announced plans to give a facelift to the storefronts and arcade of the theater. About the same time, these bonds were issued by Trust Company Bank on the company's behalf, although it is unclear if the bonds were to help finance the remodel. The work never took place. (Fox Theatre.)

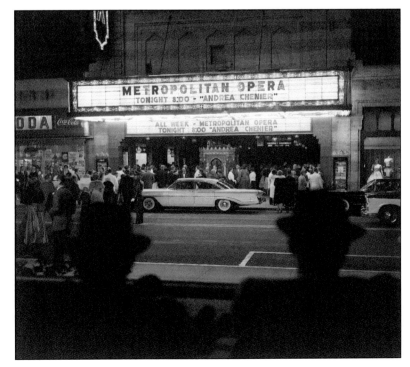

Another sign that life was returning to normal was the return of the Metropolitan Opera. The "Met" had ceased its travel during the war but returned to the Fox in 1947. In 1948, the Met and the Fox signed an agreement in which the opera would return for one week each spring, a practice that continued for 20 years. (AHC.)

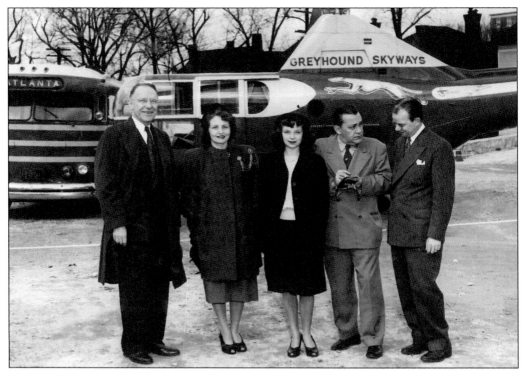

In 1947, Greyhound was developing its Skyfleet when this Sikorsky S-51 helicopter made its landing in the Fox parking lot. Part of a nationwide venture, the Skyfleet was designed to be a 14-seat airbus that would do short hops between major airports around the country. On this inaugural Atlanta flight, Mayor William Hartsfield, Mrs. Eugene Talmadge ("Miss Mitt"), and Mrs. Herman Talmadge (Betty) were on board. They are pictured above from left to right with Tommy Read on the far right next to an unidentified man. Pictured below is the first-ever landing of a helicopter in downtown Atlanta, and the group was greeted by a host of dignitaries, including entertainer Danny Kaye, who was playing the Fox. Mayor Hartsfield predicted, "The time will come when the problem of parking aircraft will be as important as our present problem of parking automobiles." The costly venture only lasted a few years. (Both, Missy Leypoldt.)

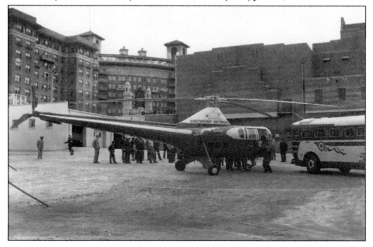

The year 1948 also meant another major change for the Fox. After years of leasing space, the Shriners of the Yaarab Temple were able to again afford a mosque of their own. They purchased the property that had been the Standard Club at 400 Ponce de Leon Avenue. Fifteen years later, the building was completely destroyed by fire. (AMLM.)

When *Wabash Avenue* came out in 1950, Fox owners Mosque, Inc., were again preparing to make changes in management. Within a few months, they had leased operations of the Fox to Wilby-Kincey Service Corporation. The company was operated by Robert Wilby and Herbert Kincey. Wilby ran the Fox back in 1933 and had gone on to operate a large chain of theaters. Wilby-Kincey operated the Fox until 1975. (Fox Theatre.)

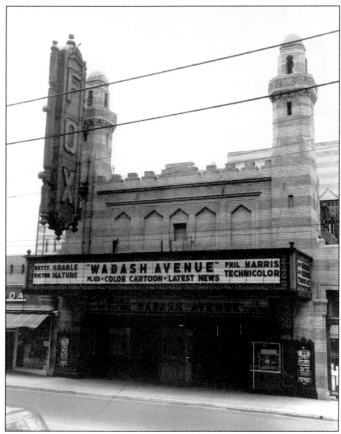

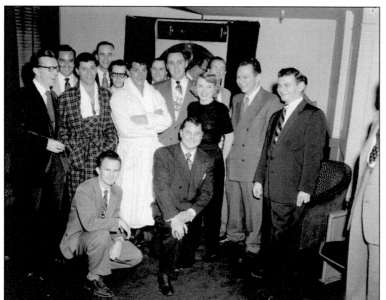

The comedy team of Martin and Lewis made an appearance at the Fox on December 1, 1951. Jerry Lewis and Dean Martin are seen here backstage in their robes with the staff of Capitol Records distribution. Three days after their performance, Martin and Lewis were back in Hollywood to work on their sixth movie together, *Jumping Jacks.* (GSU.)

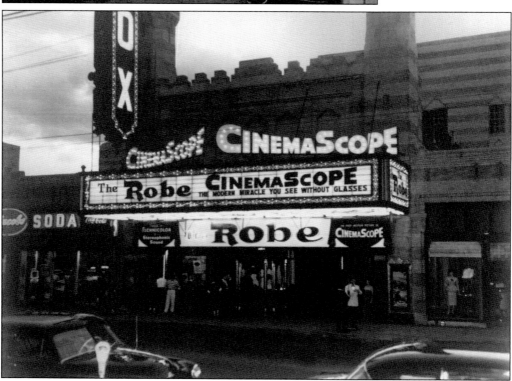

Fox Theatres across the nation premiered the movie *The Robe* in October 1953. The Southern premiere took place at Atlanta's Fox on October first. Installation of what was purported to be the "largest curved Cinemascope screen in the world" meant limited use of the Fox for little else besides movies. The 70-foot-wide iron frame was all but impossible to move. The exception was when the Met came each spring. (GSU.)

The *Atlanta Constitution* ran advertisements building up to the appearance of "Singing Sensation" Elvis Presley on March 14 and 15 in 1956. Elvis's show was considered a variety act and also featured comedians Rod Brasfield and Uncle Cyp, as well as Grand Ole Opry stars Mother Maybelle and the Carter Sisters featuring June Carter and the Wilburn Brothers. They played three shows daily between screenings of *The Square Jungle*, starring Tony Curtis. (Graceland.)

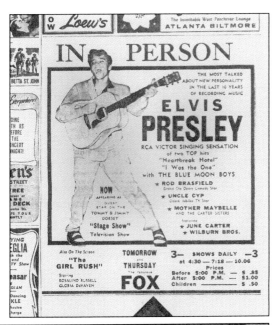

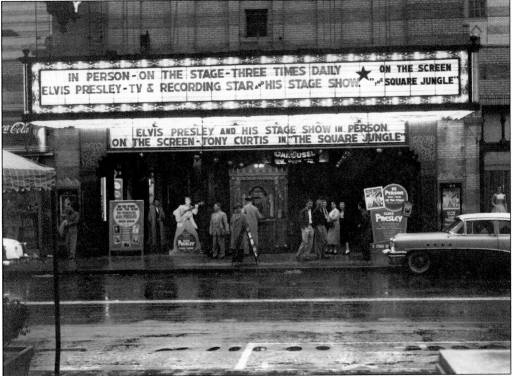

Elvis had not yet made any movies of his own. *Love Me Tender* would come out later that year, and newspaper reports declared teenage girls were "agog" over him. Many had to be turned away from the sold-out performances. Tickets sold for as little as 50¢ for children. It was later reported that Elvis earned $1,831.54, or half of the net proceeds of the two-day show. (AHC.)

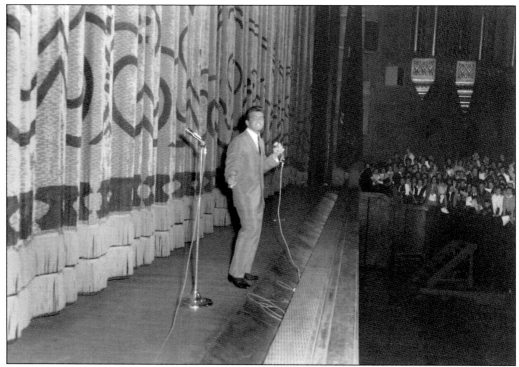

Elvis wasn't the only teen idol to send the girl swooning at the Fox. In October 1959, Fabiano Anthony Forte, better known as simply "Fabian," played to a packed house at the Fox. With his stylish good looks, Fabian was considered one of the top teen idols of the era. The year 1959 was considered his pinnacle year due to his million-selling single "Tiger." (GSU.)

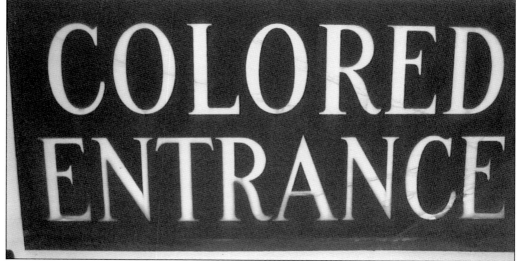

This sign hung over a separate entrance on the Ponce de Leon Avenue side of the Fox where black patrons were relegated to both purchase their tickets and enter. Due to laws of segregation, African Americans were forbidden to mix with the rest of the audience. The Fox had an area in the top balcony with 188 seats for black theatergoers. (Fox Theatre.)

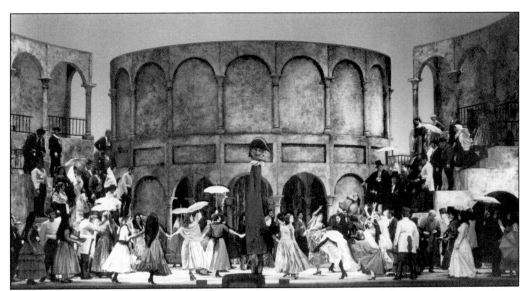

In 1962, the manager of the New York Metropolitan Opera informed the Fox that it would no longer play before a segregated audience. Former mayor William Hartsfield worked with theater owners and black leaders to come up with a desegregation plan. On May 5, 1962, a "controlled desegregation" took place in four of Atlanta's downtown theaters, with the rest of the town schedule to follow suit on June 1. (Emory Special Collections.)

In 1964, a year after fire destroyed its headquarters, the Yaarab Shrine announced that it had approved plans for a new mosque in the same location. In September, the construction bid was awarded to Ira H. Hardin for a total construction price of $700,000. The new mosque incorporated the same Arab theme that the Fox had featured but was considerably smaller and less elaborate. (AHC.)

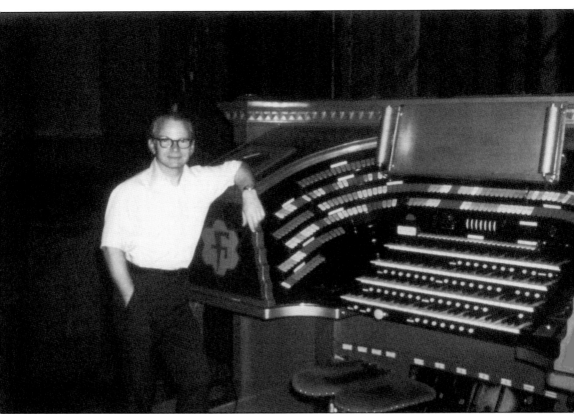

After years of neglect and almost a decade of not being played, attention was turned to the Möller organ in 1963. Under an agreement with the American Theater Organ Society's local chapter, engineer Joe G. Patten was brought in to restore the Mighty Mo. The work was done entirely on a volunteer basis, with the Fox paying the cost of parts. It took Patten 10 months to complete the task, cleaning out years of dirt from the organ's five chambers and replacing miles of wiring. But as adept as he was at repairing the Mo, he has never been able to really play her. Patten has been fascinated by organs since he was a child and even took lessons for a while. As he put it, "I never could play it like I heard it in my head, so I let other people play, and I will fix it so they can." (Fox Theatre.)

Because Patten worked a regular job, repairs to the organ were made during off hours when there was no audience around. He used the opportunity to explore and learn every nook and cranny of the building. With his talent for fixing things, he began making other repairs and offering suggestions on how to improve technical functions. Patten became the unpaid and unofficial technical director for the theater for the next 11 years. (Joe Patten.)

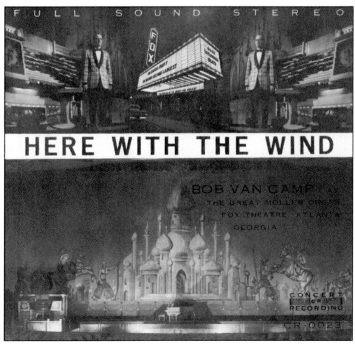

Organist Bob Van Camp worked with Patten in the quiet of the theater after hours. In 1968, the two taped their sessions and compiled them as a record called *Here With the Wind: Mighty Mo Plays.* After Van Camp's death in 1990, Patten had the recordings digitally remastered, and in 1997, a double CD was released entitled *The Atlanta Fox Theatre Remembers Bob Van Camp at Its Mighty Möller Pipe Organ.* (American Theater Organ Society [ATOS].)

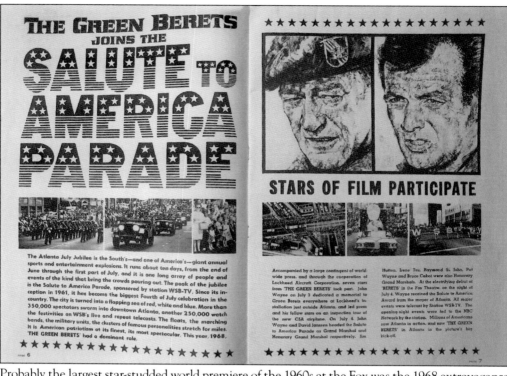

Probably the largest star-studded world premiere of the 1960s at the Fox was the 1968 extravaganza surrounding the release of *The Green Berets*. These inserts are part of the promotional material distributed by Warner Bros. following the premiere. John Wayne attended the event, which coincided with the Fourth of July. He served as grand marshal to WSB's *Salute to America Parade* prior to the movie gala. The film was near and dear to Wayne's heart, and with the war in Vietnam ramping up, he wanted to garner support for the military. Also starring David Jansen and Jim Hutton, the movie was produced by Wayne's son Michael. Part of *The Green Berets* was shot in Georgia in and around Fort Benning. (Both, Fox Theatre.)

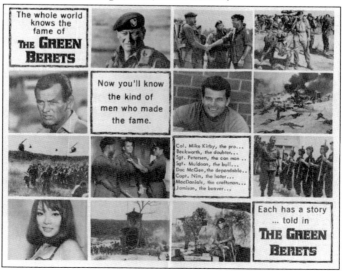

Three

THE MIGHTY MO

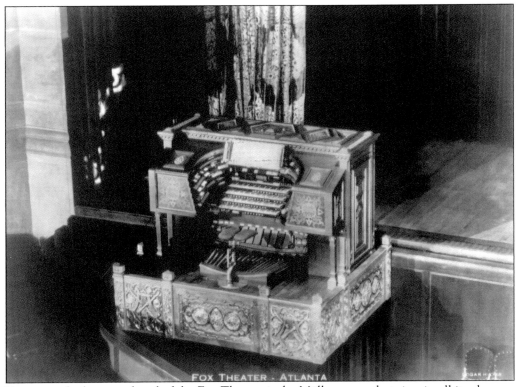

For many, the heart and soul of the Fox Theatre is the Möller organ that rises in all its glory on a lift from beneath the stage for performances. When the Fox was built in 1929, theater organs were as important a part of the theater as the screen itself. With 42 ranks, the Fox's organ was, at that time, the largest theater organ in the world. Its cost was $42,000. (Fox Theatre.)

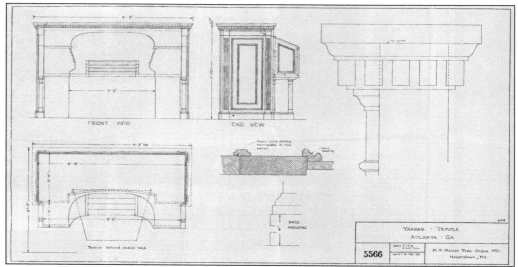

This blueprint shows the original design by M.P. Möller, Inc., of Hagerstown, Maryland, after the Shriners of the Yaarab Temple placed their order. The American Association of Theatre Organ Enthusiasts maintains those constructing it were so enthusiastic about what they wanted it to be that they continued to tweak the design almost until it was shipped, The date on these drawings is April 30, 1929. (Fox Theatre.)

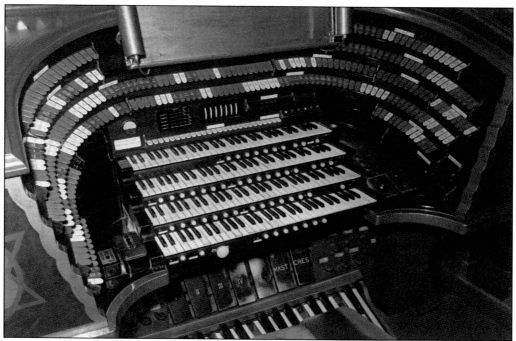

Theater organs were designed to entertain the audience in a day where the movies themselves were silent. They could take the place of an entire orchestra and could also perform sound effects. Each of the 376 stop tabs here represents a different sound. Among them are songbirds, sirens, sleigh bells, Chinese blocks, and even a bell from a 1928 locomotive. The incredible range of sounds helped earn the organ the nickname "Mighty Mo." (Fox Theatre.)

This is a copy of the "blower card" created when the organ was tested in 1929 for operation. The Möller is an electric organ, and this sheet notes its 30-horsepower motor. Surprisingly, that motor, while adequate, was never powerful enough to allow the organ to perform to its fullest. When Joe Patten refurbished the organ in the 1960s, he replaced the old blower with a 75-horsepower motor. (Fox Theatre.)

The back of the card has the specifics about the cost of the generator and blower and reveals the organ's official model name as "Opus 5566." Möller conducted its testing on May 7, 1929, and on June 27, it was shipped to the Yaarab Shrine Temple, just shy of six months before the Fox's grand opening on December 25. (Fox Theatre.)

Test Report

Style 4 L Z M.	Blower No. R-205-B
Motor Century	No. 908959 H. P. 30
Volts 220 R. P. M. 1150	Phase 3 Cy 60
Generator Ele Spec	No. 83314
Amp. 75	Volts 11 R. P. M. 1150

Direct Connect [x] Ext. Shaft [] Pulley x

Fans. R. H. 2 Diam. 38 Width 3

Fans. L. H. 2 Diam. 38 Width 3

Rated Capacity 4500 Cu. Ft. @ 15 Press.

" " ____ Cu. Ft. @ ____ Press.

" " ____ Cu. Ft. @ ____ Vac.

Discharge { Volts — Discharge { Volts —
Closed { Amps. — Open { R. P. M. 1182

Load Amps. ____ Rated Amps. ____

Generator Volts 11½ Amps. ____

Static Pressure { High 28⅛ Opening { High 45/8 16 — 24
{ Low ____ { Low x —
{ Vac. ____ { Vac. x —

Cu. Ft. { High 7696 Less 15% { High 6541
{ Low ____ { Low ____
{ Vac. ____ { Vac. ____

Shipped to M. P. Moller
For Yaarab Temple A.A.O.N.M.S.
City Atlanta State Ga.
Remks. 2½" Shaft - 55 lb shoulder.
Tested by Cravens Date June 26 29
(over)

Organ #5556 SLOWER NO. R-205-B

TOWN Atlanta, STATE Ga. CUST. ORDER NO. 5566 DATE 5/7/29

CUSTOMER M. P. Moller Organ Co., ADDRESS Hagerstown, Md.

BLOWER FOR Yaarab Temple A.A.O.N.M.S ADDRESS Atlanta, Georgia.

ORGAN Moller ACTION Electric CHEST____ EXT. SHAFT____

WIND 4500 AT 15" | AT | AT | BELT____ PULLEY____

STOPS____ | SUBS____ | SUPERS____ | PROMISED at once

BLOWER SIZE 4 LZM % COM. TO____ $____

MOTOR A.C. D.C. R.P.M. 1150 H. P. 30 V. 208 PHASE 3 CYCLES 60

MOTOR MAKE Century NO. 908959 STARTER____

GENERATOR MAKE Elec. Spec. NO. 83314 V. 10 12 A. 45 69 SPEED 1150

VALVE no B. & F. JOINT 16" PIPE____ FT.____ L's____ FLANGES____

PRICE BLOWER $952 56/100 O. B. GEN. $84160 D/C $15 00 ERECT.____ WIRING NO YES

SHIP VIA Freight.

DATE SHIPPED 6/27/29 CARE____

FORM 107 3M 6-26 TERMS____

On List

This advertisement was placed in the *Sunday American* newspaper by M.P. Möller, Inc., the week the Fox opened. The Möller company, a prolific builder of organs, had the world's largest organ factory. It constructed more than 11,000 organs in its 117 years of operation, but the Fox's Mo was unique, even by Möller standards, and the company was obviously proud of the finished product. The vast majority of its organs were built for churches. The Mighty Mo is one of just 12 in its entire history that Möller built for theaters. Its makers designed it to be able to function as either a theater or a church organ. (Fox Theatre.)

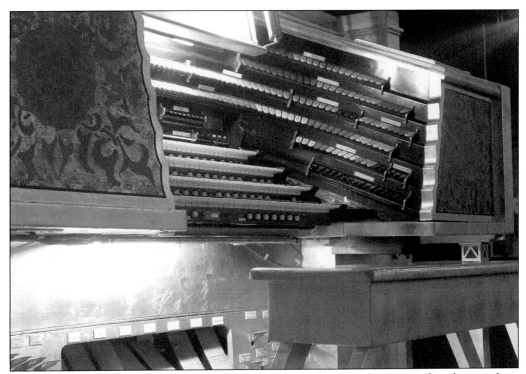

The organ's golden appearance is attributed to real gold. The parts that are not hand painted are covered in 22-carat gold leaf. The intricate carved detail can be attributed to the fact that M.P. Möller began his career as a woodcarver and put his skills to work at the Felegemaker Organ Company in Erie, Pennsylvania, before starting his own organ company in 1875. (Hal Doby.)

Moving the massive organ was not exactly an option. For that reason, the Mo was installed on top of one of the Fox's six mechanical lifts, which can raise or lower the organ even while the organist is playing. The lifts were designed by Peter Clark, who also designed the lifts for Radio City Music Hall in New York. (Fox Theatre.)

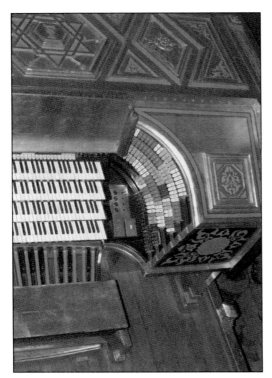

In 1933, Radio City Music Hall surpassed the Fox's Möller as the world's largest organ by installing a 53-rank Wurlitzer. Still, no organ has yet to top the Mo's console size with its 376 stops. It is so large, in fact, that once completed, there was not an exit at the Möller factory big enough, and a wall of the factory had to be partially demolished to get it out. (Fox Theatre.)

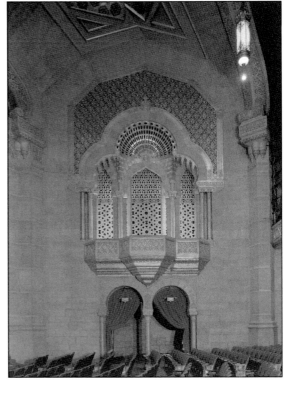

The ornate screens behind the faux balconies on either side of the stage were designed to conceal the organ's five instrument chambers. There are two chambers on the left and three on the right, containing four manuals, 42 ranks, 3,622 pipes, and a host of actual instruments. Pipes range in size from as small as a pencil to 32 feet tall and large enough for a man to stand in. (Fox Theatre.)

Each of the five organ chambers has its own distinct functions and sounds triggered by keys on the keyboard that operate electromagnetic switches, opening or shutting ducts to trigger pipes or instruments. Organ chamber E is the smallest of the five and is located on the right side of the stage. Among the sounds it houses are the open diapason, flute harmonic, stopped diapason, small trumpet, oboe, salicional, and dulciana. (Michael Portman.)

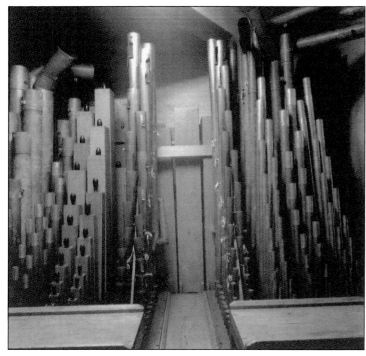

Some of the chambers, like chamber A, contain real instruments and objects wired to the organ to create sound effects. Only part of the two-story-tall A is shown here. It includes the bass drums, cymbals, tambourines, sleigh bells, triangles, and castanets, as well as the kinura, chimney flute, orchestral oboe, clarinet, solo violins, three ranks, and a steamboat whistle. (Joe Patten.)

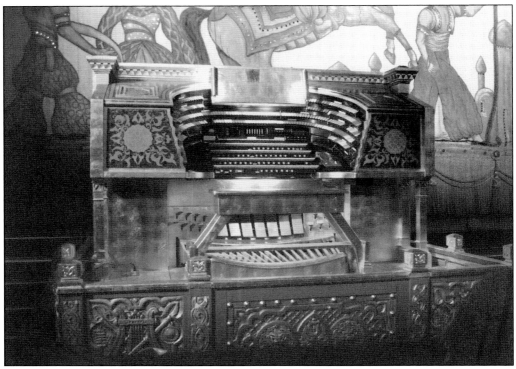

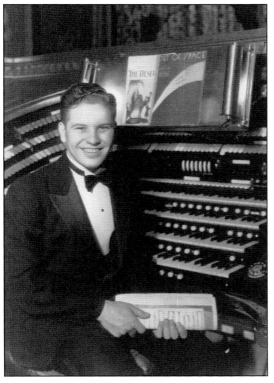

When the Fox opened on Christmas Day, 1929, the first thing to entertain the audience was Iris Wilkins showing off the incredible capabilities of the Möller organ as they rose from the orchestra pit. The Fox began broadcasting concerts four times a week on WSB Radio at 11:30 a.m. Iris and her husband, Don, were the theater's first organists, followed in June 1930 by Dwight Brown, also know as "the Organ Ace." (Elbert Fields.)

Dale Stone came to the Fox in May 1935 following a few tumultuous years of financial uncertainty at the theater. The Rome, Georgia, native played live radio shows Monday through Friday at 11:45 a.m. According to ads in the *Atlanta Constitution*, the program featured "popular music" and was based entirely upon requests. In the 1950s, Stone was the official Georgia state organist. (Fox Theatre.)

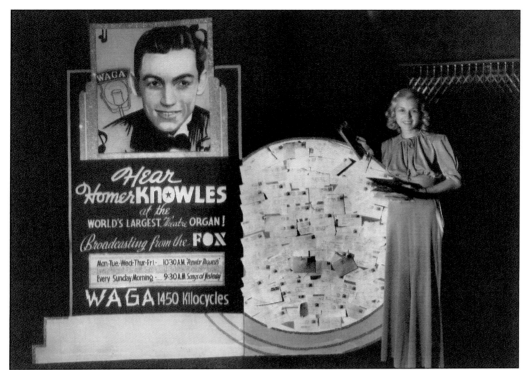

When organist Homer Knowles came to the Fox in July 1936, a huge ad campaign ensued. Also a Georgia native, Knowles had studied in Chicago, and his daily sing-alongs proved very popular among the audiences. The woman next to this elevator lobby display is Bobbie Hannah, who was a Fox cashier. When Knowles was inducted into service in World War II, he was the Fox's longest-lasting organist. (Fox Theatre.)

At a time when African Americans were relegated to the "colored" section of the Fox's balcony, Graham Jackson was packing in audiences. The black organist, pianist, and conductor was internationally acclaimed for his style and talent. In 1971, he became the official musician of the State of Georgia. The iconic photograph of a tearful accordion player at Pres. Franklin D. Roosevelt's funeral procession in 1945 is of Jackson, a friend of FDR. (Fox Theatre.)

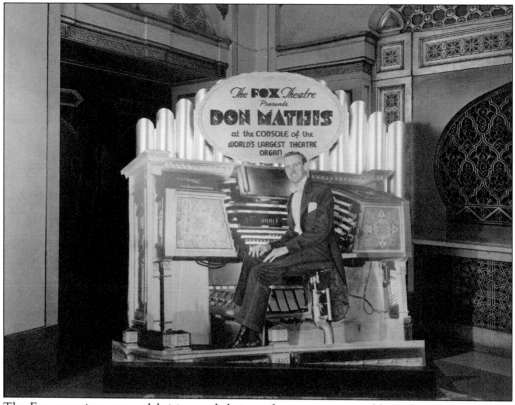

The Fox organists were celebrities, and their performances were publicized accordingly. This display from 1944 is for Don Mathis. In addition to playing the organ, Mathis was also a composer. Georgia Tech's *Technique* newspaper noted in its September 1944 issue the introduction of Mathis's song "In My Memory," which was sung by football tenor Tex Ritter. (Fox Theatre.)

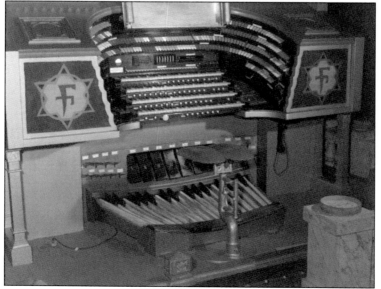

While the Mo's music and organists had been popular, maintenance on the instrument had not been a priority. Wear and tear took its toll, and as wires connecting keys and stops started breaking or becoming disconnected, they were not properly repaired. By 1954, the organ was so neglected that it simply stopped working altogether. (Fox Theatre.)

In 1962, the American Theater Organ Society asked Fox manager Noble Arnold if it could do a formal inspection of the organ. In February 1963, the society delivered its assessment. The organ itself was in good shape, but the cables connecting the console to the relay box to operate the various keys and stops was in terrible condition. The members offered to do the repairs for free if the Fox would provide the materials. (Fox Theatre.)

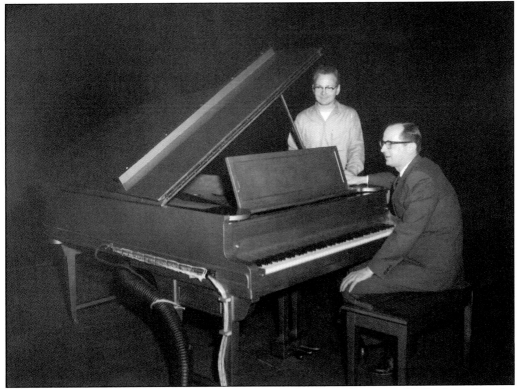

Bob Van Camp was vice chairman of the ATOS's southeastern chapter and helped conduct the assessment and negotiate with Arnold. He enlisted electrical engineer and organ enthusiast Joe G. Patten to head up the team to do the work. The first order of business was cleaning out the chambers for what appeared to be the first time in 33 years. (Fox Theatre.)

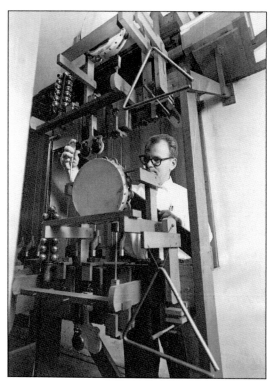

The Fox was still showing movies, so the volunteers would work after the theater closed until the wee hours of the morning. Patten spent 10 months and thousands of unpaid hours putting stronger cabled wires to each of the organ's 244 keys, 32 pedals, 3,622 pipes, 120 shutters, and their respective power supplies. It's estimated that as much as seven miles of wire was used in the rewiring. (Fox Theatre.)

As long as the function was being restored, Arnold opted to also give the Mo itself a bit of a facelift. He had the staff painters touch up any chipped or broken ornamentation and put new covers on the pedals and the seat. Then, for good measure, he had the exterior regilded so it would shine for its comeback performance. (Fox Theatre.)

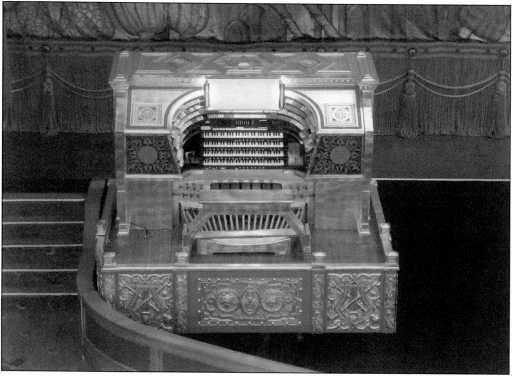

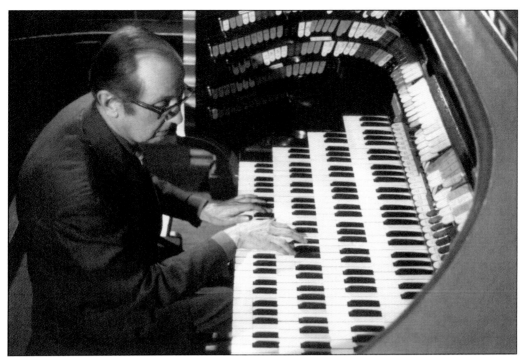

When it came time for the world to hear the Mighty Mo again, Bob Van Camp was at the keyboard. The premiere was set for November 23 1963, but when Pres. John F. Kennedy was assassinated the day before, the show was delayed for five days. On Thanksgiving Day, at 3:30 p.m., the Mo rose for the first time in a decade to the strains of Van Camp playing "Georgia On My Mind." (Fox Theatre.)

In addition to all of the instruments hidden in the chambers of the stage, the Möller organ also controls a six-foot Baldwin piano. While pianos had been played along with the Mo over the decades, the Baldwin was not wired to the organ until 1965, when Joe Patten relocated the piano from Chicago's Piccadilly Theatre. (ATOS.)

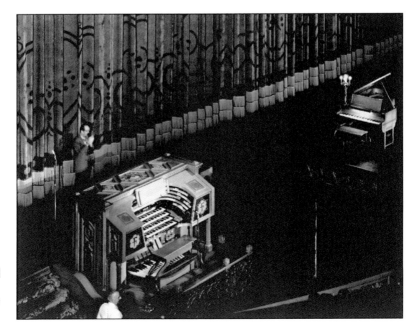

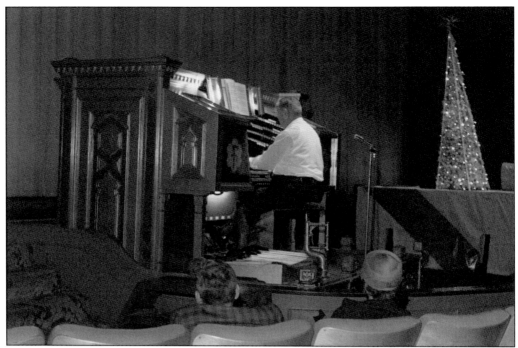

ATOS president "Tiny" James is shown here performing with the Möller. James and regional vice president Erwin Young had spearheaded the initial move to restore the organ. Part of the agreement was that the ATOS could have occasional use of the Mo. A renowned artist in his own right, James was also among the final performers when the San Francisco Fox Theatre closed its doors on February 16, 1963. (Fox Theatre.)

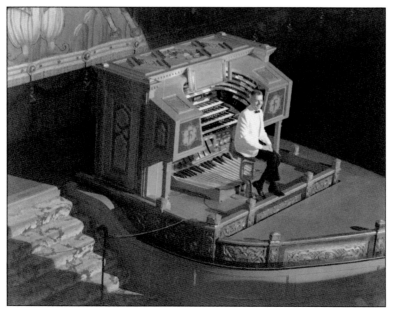

With the restoration complete, the Mighty Möller organ gained celebrity status among not just organ enthusiasts but also among organ players themselves. Billy Nalle returned several times to play at the Fox. A member of the ATOS Hall of Fame, Nalle performed when the American Guild of Organists held its annual meeting at the Fox in 1966. (Fox Theatre.)

The youngest person known to master the Mo was Robbie Irvin. A neighbor of Joe Patten, he was just 11 when he begged Patten to take him to the theater. The boy was immediately attracted to the organ, even though he had no musical training. With help from Bob Van Camp, he learned quickly, first playing in public at a kiddie matinee in 1970. He was listed as a staff organist for several years. (Fox Theatre.)

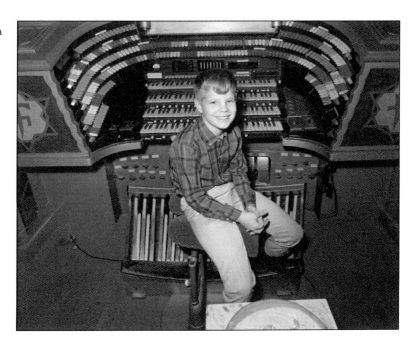

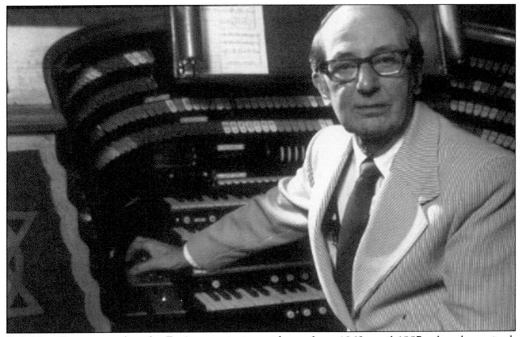

Bob Van Camp served as the Fox's organist in residence from 1963 until 1987, when he retired. A founding member of Atlanta Landmarks, Inc., which saved the Fox from destruction in the 1970s, he was also a well-known local radio and television personality. When Van Camp passed away in 1990, his memorial service was held at the Fox. His ashes were later scattered in the organ's chambers. (Fox Theatre.)

After the Fox was saved from destruction in the 1970s, its owners began utilizing it at every opportunity. The American Theatre Organ Society hosts regular concerts highlighting the Mo's capabilities. A summer film series begun in the 1990s was preceded by an old-fashioned sing-along in which words would show on the screen while a bouncing ball prompted the audience to sing along with the Mighty Mo. (Fox Theatre.)

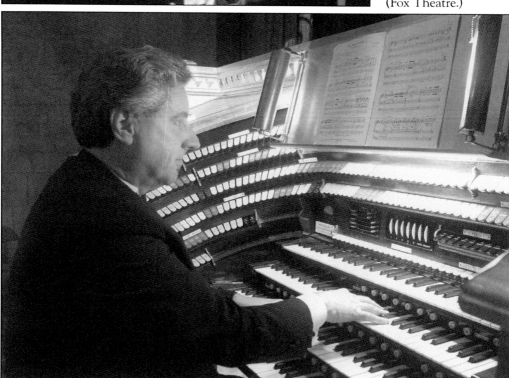

Organist Dennis James became another regular for silent film presentations and the summer film festival. Internationally known for his accompaniment of silent films, he is credited with starting a revival of sorts of their presentation. During the 1980s, James traveled on a nationwide tour with silent film stars Lillian Gish and Buddy Rogers, providing the theatrical music to their silent films. (Fox Theatre.)

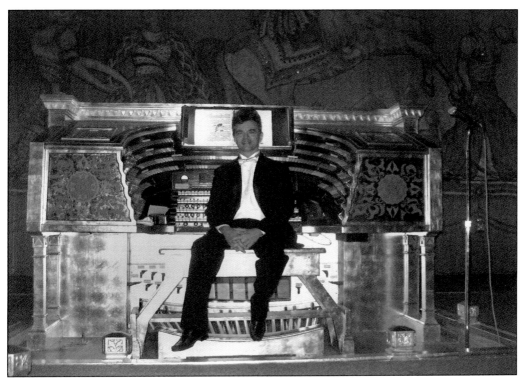

Considered one of the top touring silent film accompanists of the day, Clark Wilson began coming to the Fox in the 1990s to play the Mighty Mo in special silent film presentations. As in the early days of the theater, the organ would set the mood according to what was occurring on screen, utilizing a host of real instruments hidden in the organ chambers and special sounds such as whistles, bells, and sirens. (Fox Theatre.)

Larry-Douglas Embry was named organist in residence at the Fox in 2002, the first person to hold that position in more than two decades. Among his duties is helping educate visitors to the Fox about the Mighty Mo and performing prior to scheduled Fox shows such as the Broadway stage series, the Atlanta Ballet's *Nutcracker* each winter, and the summer film festival. (Sarah Foltz.)

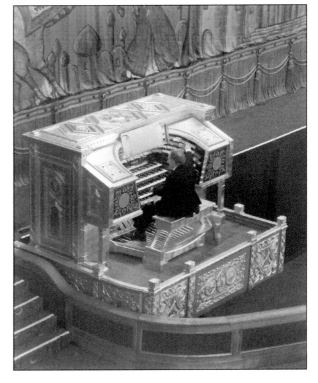

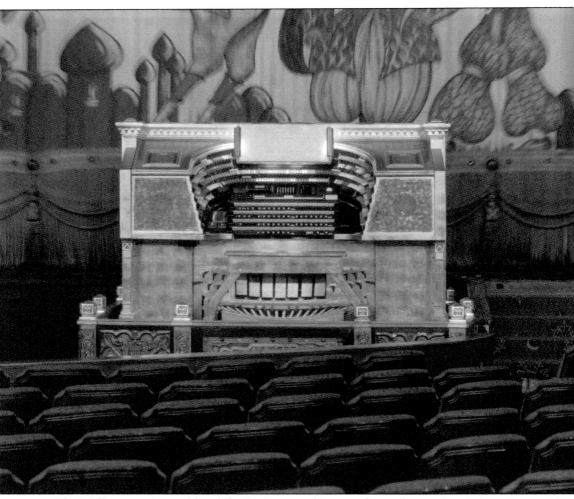

The Möller organ is considered the Fox's star and is treated as such. Anytime it is not in use, it's lowered on its own elevator to the basement below and encased in a protective hard covering, away from prying eyes and potential damage. Each time the organ rises, it is carefully wiped down to maintain the gilded shine. Joe Patten meticulously maintained it until his retirement in 2002. A testament to Patten's 1963 work was that 50 years later, there has been only one wire failure. Bought for $42,000, it is virtually impossible to put a price tag on the organ, because the Mighty Mo is considered irreplaceable. (Fox Theatre.)

Four

SAVE THE FOX

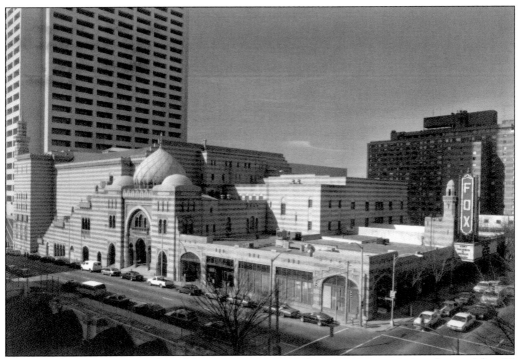

By 1970, the Fox was struggling. Moviegoers were spending more time in cineplexes. After 19 years as general manager, Noble Arnold retired. At that time, his tenure in that position was a record. His white-glove efficiency was quickly missed, and the maintenance of the theater slowly declined. (Fox Theatre.)

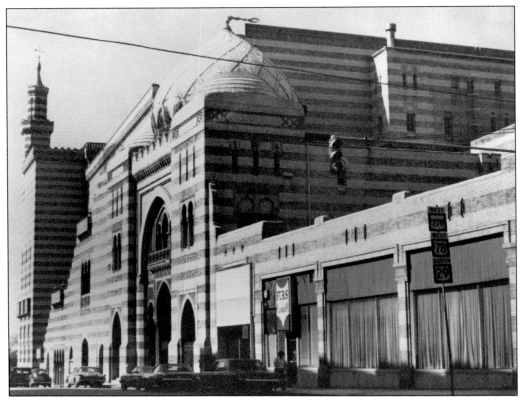

For some time, Mosque, Inc., had been looking to find a buyer for the Fox. At the same time, Southern Bell was seeking property to construct a new building upon, having outgrown its downtown offices. Ironically, the Bell building, which was erected in 1929 and was Atlanta's first skyscraper, was designed by architects Marye, Alger, and Vinour, the same firm behind the Fox. (AHC.)

Southern Bell wanted a Peachtree Street address, and it reached an agreement with Mosque, Inc., to take what Mosque considered a white elephant off its hands. Southern Bell purchased the Fox for $3.5 million. The deal was kept quiet while plans were being put into place to implode the Fox without notifying the public. The plan had to be approved by the Atlanta Civic Design Commission, and several members did not approve. (Fox Theatre.)

Within days of the plan for destroying the Fox being put before the commission, hundreds of students appeared on the sidewalk in front of the Fox to voice frustration and demand the demolition be halted. Among the organizers were Rodney and Laura Cook, the children of Civic Design Commission member Bettijo Cook. The demonstration was the first public pronouncement of the Fox's potential fate. As word spread, so did condemnation of the plan. (Rodney Cook.)

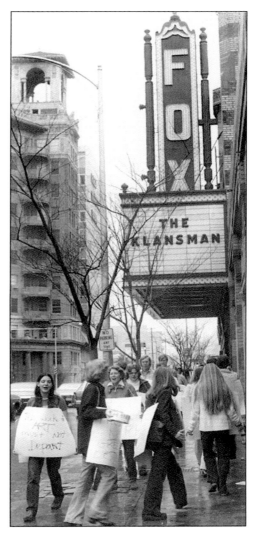

It was a fight that was described by Beauchamp Carr as "intense drama, with intense feelings." Mosque, Inc., was anxious for the sale to go through so it could get out from under its debt. Southern Bell's relative real estate bargain had proven to be a public relations nightmare. People were sending in checks to pay their telephone bill and scrawling "Save the Fox" across them. (Fox Theatre.)

This is the application to have the Fox placed in the National Register of Historic Places, a feat accomplished in May 1974. Generally, buildings less than 50 years old are not eligible for the status, but an exception was made because of the Fox's "outstanding Architectural Merit." The status, while impressive, does not mean that a building is protected from being destroyed. (Fox Theatre.)

Form No. 10-300 (Rev. 10-74)

UNITED STATES DEPARTMENT OF THE INTERIOR
NATIONAL PARK SERVICE

NATIONAL REGISTER OF HISTORIC PLACES
INVENTORY -- NOMINATION FORM

FOR NPS USE ONLY

RECEIVED

DATE ENTERED

SEE INSTRUCTIONS IN *HOW TO COMPLETE NATIONAL REGISTER FORMS*
TYPE ALL ENTRIES -- COMPLETE APPLICABLE SECTIONS

1 NAME

HISTORIC
FOX THEATRE

AND/OR COMMON

2 LOCATION

STREET & NUMBER
660 Peachtree Street, N.E. NOT FOR PUBLICATION

CITY TOWN
Atlanta VICINITY OF CONGRESSIONAL DISTRICT
 5th

STATE CODE COUNTY CODE
Georgia Fulton

3 CLASSIFICATION

CATEGORY	OWNERSHIP	STATUS	PRESENT USE
X DISTRICT	X PUBLIC	X OCCUPIED	__AGRICULTURE __MUSEUM
__BUILDING(S)	__PRIVATE	__UNOCCUPIED	X COMMERCIAL __PARK
__STRUCTURE	__BOTH	__WORK IN PROGRESS	__EDUCATIONAL __PRIVATE RESIDENCE
__SITE	PUBLIC ACQUISITION	ACCESSIBLE	X ENTERTAINMENT __RELIGIOUS
__OBJECT	__IN PROCESS	X YES RESTRICTED	__GOVERNMENT __SCIENTIFIC
	__BEING CONSIDERED	__YES UNRESTRICTED	__INDUSTRIAL __TRANSPORTATION
		__NO	__MILITARY __OTHER

4 OWNER OF PROPERTY

NAME
Atlanta Landmarks, Inc. 30308

STREET & NUMBER
Fox Theatre Building

CITY TOWN
Atlanta VICINITY OF STATE
 Georgia

5 LOCATION OF LEGAL DESCRIPTION

COURTHOUSE
REGISTRY OF DEEDS, ETC Fulton County Courthouse

STREET & NUMBER

CITY TOWN
Atlanta STATE
 Georgia

6 REPRESENTATION IN EXISTING SURVEYS

TITLE
National Register of Historic Places

DATE
1974 X FEDERAL __STATE __COUNTY __LOCAL

DEPOSITORY FOR
SURVEY RECORDS National Park Service

CITY TOWN
Washington, D.C. 20240 STATE

AN OPEN LETTER TO THE PEOPLE OF GEORGIA

I recently learned of the impending destruction of the Fox Theatre, a magnificent building that is to give way for a new development. To say the least, I am not surprised.

As a nation, we have been far too careless with our heritage and our culture. We have, for much too long a time, made the arts take a back seat to what we call "progress." However, we in America have always been known as a future-oriented people -- and this is good -- no one will deny that. But in our quest for the new, we have seriously neglected those parts of our environment that reduce the stereo-typed and monotonous character that many of our cities are now taking on.

Our old theatres need not be left as derelicts, or relics of the past or even as museums. They can live and breathe and become working centers for the arts. They need not sit on some neglected corner, dark and ominous looking; they are much too proud for that. They should shine as monuments and symbols of our past.

Likewise, we must soon come to recognize that theatres like the Fox have far too much to offer to be cast aside as a "useless pile of stones". They have a character, and can infectiously affect neighborhoods, becoming prestigious centers and great sources of revenue, as well as proud monuments of our heritage. In the same way, theatres like the Fox can be a learning experience for everyone of all ages. Where else could a ten year-old see a "real live" movie palace of the 1920's? A fifteen year-old the glitter and gild of an age that was so imaginative? And more than that, where does anyone find the care and craftsmanship such as is so visibly demonstrated in the "Fabulous Fox" today? Indeed, in terms of cost alone, one could not even contemplate the costs of building such a fantasy-world movie palace in today's market, complete with clouds, suns, moons, mosques and crenellated castle walls. Nothing could ever replace this work of art - this national treasure. For these reasons, we cannot afford it at any cost, to let the Fox go.

Reasonable, economic solutions can be found -- they have been found for other great buildings in the past. Stop and think before it is too late -- we have done far too much damage already to our cultural heritage. The Fox is of inestimable value to the people of the City of Atlanta, the State of Georgia and of the United States. It must be preserved in perpetuity at all costs. We must "Save the Fox".

Helen Hayes

July 19, 1974

Lucy Kroll Agency
390 WEST END AVENUE
NEW YORK, N. Y. 10024

One of the most respected actresses of the day could not keep silent. Helen Hayes, considered the "first lady of the theater," wrote an open letter to the citizens of Georgia chastising them for being "careless" with such a treasure and pleading with them to save it. She deemed the Fox as invaluable not just to Atlanta or the state but to the United States as a whole. (Fox Theatre.)

The chairman of the State of Georgia's tourism committee, Sen. Floyd Hudgins of Columbus, hosted a public hearing to see how the state might be involved. More than 1,000 people attended the hearing. Hudgins was in favor of using state moneys on the project to preserve the theater, but Mosque, Inc., president John Stembler declared that "In all possibilities, when the smoke clears, the building will likely be demolished." (Fox Theatre.)

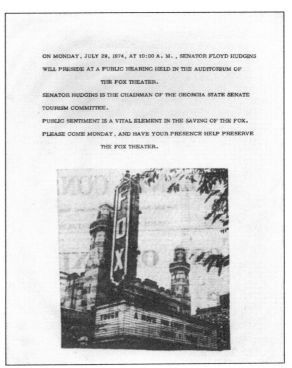

In August 1974, Atlanta Landmarks, Inc., was officially incorporated for the express purpose of saving the Fox. As Beauchamp Carr would later say, "We had no money and no credibility," but they did have passion. Its 22 trustees were determined to fight for the Fox, despite the fact that, legally, Southern Bell's commitment to buy the theater was still in place. (Fox Theatre.)

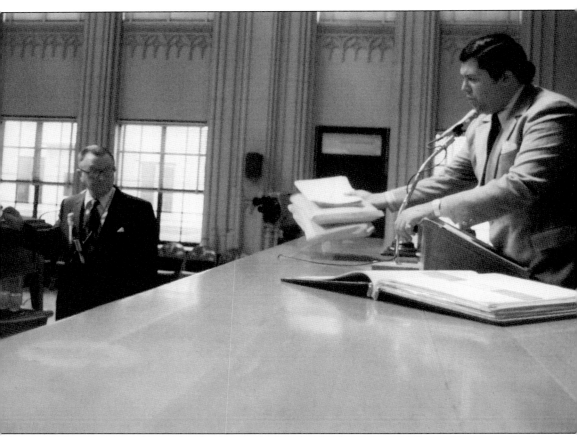

The immediate fate of the Fox was in the hands of Atlanta mayor Maynard Jackson, who had to decide whether to sign the demolition permit. Having grown up in segregated Atlanta, he had never gone as a child, yet he recognized the theater's importance. He refused to issue the permit, granting an eight-month "stay of execution" to give those seeking to save the Fox a chance to develop a plan. On July 10, the mayor held a Save the Fox meeting at Herren's restaurant. Among those in attendance were Brad Curry, Ed Noble, Bettijo Cook, William Pressley, John McCall, Bob Foreman, Bob Van Camp, Charles Walker (longtime Fox glass and light artisan), Pat Connell, Joe Tanner, William Griffen, Bill Hamilton, Lee Dunagen, Joe Patten, Ed Negri, and Steve Negri. (AHC.)

By December 10, a feasibility study had concluded that the Fox could successfully be run as a center for performing arts. Underwritten by the Georgia Department of Natural Resources Historic Preservation Section and costing $11,000, the report was compiled by economic consultants Hammer, Siler, George & Associates. The report stated that the Fox could become "a symbol of Atlanta's recognition of its past to complement its growth and spirit as an international city." (Fox Theatre.)

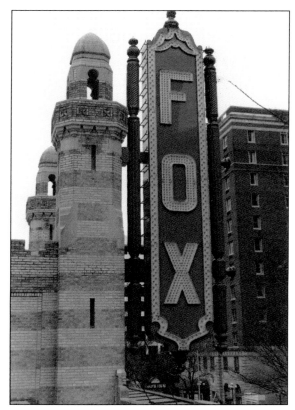

"Alex Cooley Presents" was at the top of just about every major concert ticket stub of the 1970s and 1980s. Cooley loved the Fox and joined forces with those trying to save it. During 1973, Cooley and Howard Stein began a series of midnight concerts at the Fox that continued through 1974. On December 31, Cooley presented the Gregg Allman Tour for an audience of 4,000. (Alex Cooley Presents.)

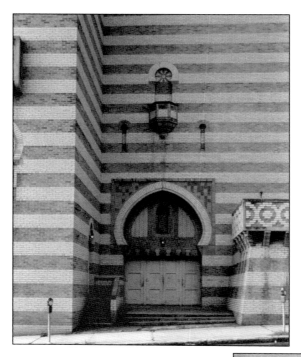

While efforts to preserve the Fox were hitting a fever pitch behind the scenes, Mosque, Inc., was continuing its efforts to get out from under owning and operating the Fox. On January 2, 1975, the Fox was padlocked after the 9:25 p.m. showing of the Lee Marvin/O.J. Simpson movie *The Klansman*. (Fox Theatre.)

This cover story for the January 1975 *Atlanta Gazette* newspaper asked the question that many were asking as well: "Will the Fox Find a Savior?" There were numerous would-be saviors putting their jobs and lives on hold to strategize and work behind the scenes, negotiating with Southern Bell to buy the building back. (Fox Theatre.)

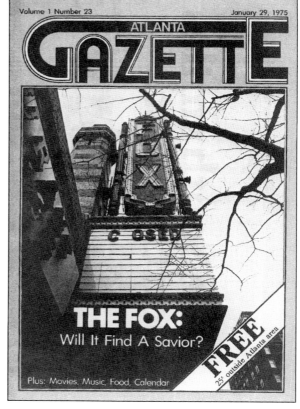

Raising the money for that buyback grew rapidly from a grassroots venture to an organized campaign. Time was of the essence, and those wanting to save the Fox knew it. In addition to seeking straight-out donations, the group attacked the problem almost as they would a political campaign. There were T-shirts, bumpers sticks, buttons, and posters sold as Atlanta Landmarks, Inc., solicited members to join. Since the building was now closed, the slogan for many was "Bring the Fox Alive in '75." The longer the Fox stayed shuttered, the more formidable the task ahead. (Both, Fox Theatre.)

**ATLANTA LANDMARKS'
VOLUNTEER SPEAKER'S BUREAU
PROUDLY PRESENTS THE LATEST
IN FOX FASHIONS —
THE FABULOUS FOX T-SHIRT**

The new design is a whimsical departure from our earlier shirt design, featuring a furry red fox with a sly expression — reflecting the survival spirit of *THE* FOX and the people who have worked to save it. Fox fanatics will recognize the art-deco logo from the 1930's proclaiming the Fox Theatre to be The Last Word in movie houses. The shirt is available in Mens, Women's and Children's sizes and an assortment of colors. (See ordering information on the coupon at left.)

HELP SAVE THE FOX . . . PERMANENTLY!

Send this form with your contribution as:
() $10.—General Membership () $25—Sustaining Membership
() $50—Sponsoring Membership () $100—Charter Membership
() Other $_____

All contributions of $10.00 or more will become mebers of Atlanta Landmarks, Inc. Members will be kept abreast of our progress and will receive advance notification of special events to be held in the Fox through out newsletter. Sponsoring and Charter Members will receive a copy of ATLANTA FOX ALBUM by John Clark McCall, Jr. — a 32-page pictorial and historical presentation of the Fabulous Fox.

Name_____
Address_____
City _____ State _____ Zip _____
For tax deduction, please make checks payable to:
ATLANTA LANDMARKS, INC.

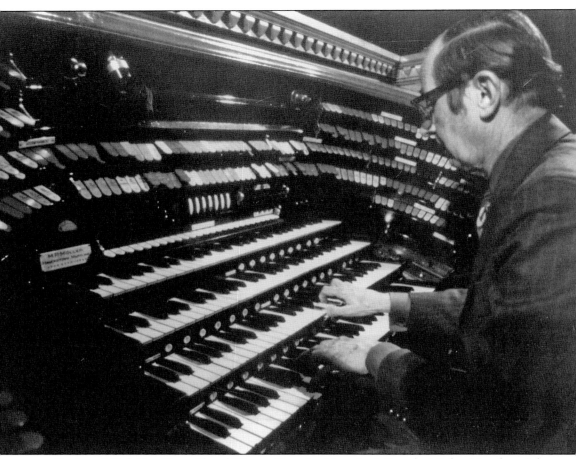

On June 3, Bob Van Camp Played "Happy Days Are Here Again" on the Mighty Mo when Atlanta Landmarks, Inc., and Southern Bell announced they had a victory to celebrate. Five Atlanta-area banks had come together to lend Atlanta Landmarks, Inc., $1.8 million to help save the Fox. The complicated arrangement involved paying off the mortgage on the Fox as well as swapping the Fox property for a plot of land on West Peachtree and Third Street. The deal was contingent on Bell getting the title to the land free and clear. If Atlanta Landmarks, Inc., missed a payment by even one day, the Fox would be torn down. The loans were finalized and Atlanta Landmarks, Inc., took possession of the Fox on June 25, 1975. (Fox Theatre.)

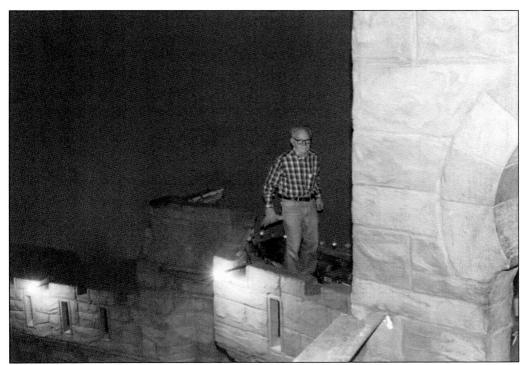

Now that it appeared the Fox could be saved, someone had to get it up and running again, and Joe Patten was the only choice. Back when rumors of the Fox's initial closing had started, Patten had started protectively locking furniture and other items away so they wouldn't disappear. In a few cases, he made people return items he saw them taking. Consequently, there are only 25 pieces of furniture missing from the original 1929 Fox inventory. He and Robert Foreman personally took out a $10,000 loan from Trust Company of Georgia to get the Fox's power restored. The Fox had been empty for months. Carpet soaked with beer and Coke had to be removed, and the whole place needed to be aired out. A lot of work was still ahead. (Above, Robert Foreman; below, Fox Theatre.)

Among those helping were a group of Atlanta's young people. Calling themselves "Youth for the Preservation of the Fox Theatre," they spent many hours down at the Fox helping clean. They also were involved in fund-raising, working on their own with Atlanta Landmarks, Inc. Many of the group had been a part of that initial protest that brought the potential demolition to the public eye. In July 1975, it held the first of what would be four annual galas in the Egyptian Ballroom, each growing bigger than the next. Posing on the edge of the stage in the ballroom in the photograph above are, from left to right, (first row) Robin Loudermilk, Laura Cook, Rodney Cook, Tricia Rayle, and Marshal MacArthur; (second row) Pam Rollins and Peck Brumby. (Above, Rodney Cook; below, Fox Theatre.)

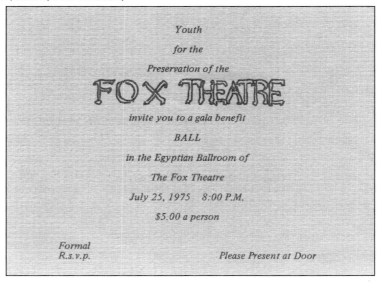

Youth

for the

Preservation of the

FOX THEATRE

invite you to a gala benefit

BALL

in the Egyptian Ballroom of

The Fox Theatre

July 25, 1975 8:00 P.M.

$5.00 a person

Formal
R.s.v.p. Please Present at Door

The Fox reopened its door to the public on September 14, 1975, for the first time in more than nine months. More than 4,000 people came during a three-hour period for tours conducted by the American Institute of Architects. Operations resumed on October 29 with a concert by Linda Ronstadt. On that night, the Fox posted a profit—something it continues to do. (Fox Theatre.)

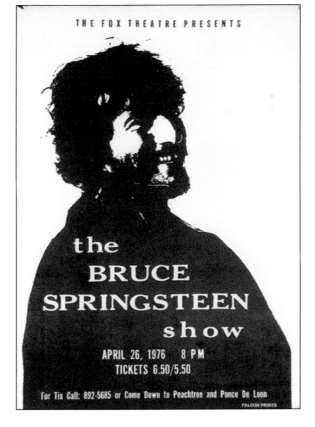

THE FOX THEATRE PRESENTS

the
BRUCE
SPRINGSTEEN
show

APRIL 26, 1976 8 PM
TICKETS 6.50/5.50

For Tix Call: 892-5685 or Come Down to Peachtree and Ponce De Leon

FALCON PRINTS

What followed over the next several months was a series of performances, concerts, and benefits, all designed to save the Fox. On March 26, 1976, Bruce Springsteen and his E Street Band played the Fox as part of their Born to Run Tour. This poster incorrectly says April, but the concert was in March. It was the Boss's first appearance in Atlanta. (Fox Theatre.)

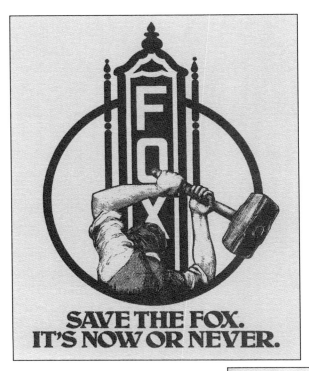

This "Now or Never" cover was Atlanta Landmarks, Inc.'s official report to help solicit the contributions. The six-page booklet noted both how far it had come and how far it needed to go to stave off the wrecking ball. While $1.8 million has been borrowed, interest and fees brought the total needed to $2 million. Through donors and the National Endowment of the Arts, it had already raised $800,000. (Fox Theatre.)

This stencil highlighting the Fox's marquee, as well as the famous Mighty Mo organ, was used on T-shirts and in fund-raising beginning in 1976. It was designed by Steve Swicegood, an architect who worked with Atlanta Landmarks, Inc., during its efforts to save the Fox. (Fox Theatre.)

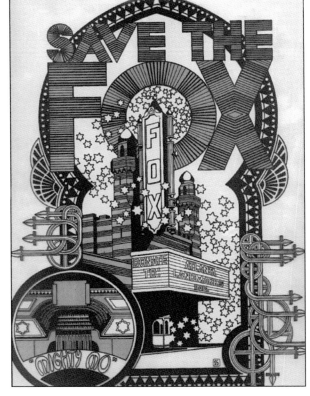

Ted Stevens, the general manager of the Fox, is shown here making a presentation prior to a benefit concert by organist Virgil Fox on March 27, 1976. The concert was sponsored by the Georgia Chapter of the American Society of Interior Designers (ASID). From left to right are Steven Ackerman, president of the Georgia Chapter of ASID; Stevens; Wayne Ladreiter, chairman of civic relations for ASID; and Bennie Howard, Fox staff. (Fox Theatre.)

HECTOR OLIVERA
FINGERS & FEET — MUSICAL MAGIC!

June 10, 8:30 pm

AT THE FABULOUS FOX MOLLER ORGAN!

OLIVERA is not *just another organist;* he's an accomplished veteran of both classical and theatre literature, a Juilliard scholar and veteran of concerts in Carnegie Hall, Cathedral of St. John the Divine, St. Thomas, and countless concerts before theatre organ groups.

TICKETS:

FOX BOX OFFICE, S.E.A.T.S.

$6.25 — $4.25 — $3.25

PRESENTED BY THE ATLANTA CHAPTER, AMERICAN THEATRE ORGAN SOCIETY TO BENEFIT THE FOX.

The Atlanta Chapter of the American Theatre Organ Society hosted its own fund-raiser, featuring Hector Olivera on the Mighty Möller organ. Internationally known for his versatility on the organ, Olivera later used the Mighty Mo as the focus of a CD entitled 660 *Peachtree Street, Hector Plays the Fabulous Fox.* (Fox Theatre.)

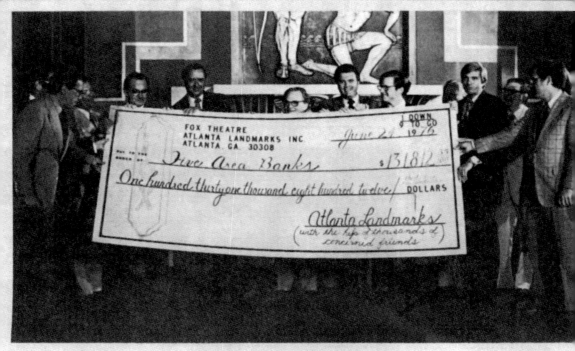

Saving The Fox

Atlanta Landmarks, Inc., dedicated to saving the Fox Theatre, last week presented this eight-foot check for $135,000 to northsider Beachamp Coppedge, acting president, in ceremonies in the Egyptian Ballroom of the Fox. The check will be used as part of a loan payment for purchase of the historic theater. (Neighbor Photo by Larry Marchant)

In June 1976, Atlanta Landmarks, Inc., had raised enough money to make its first interest payment on the Fox purchase loan. This article appeared in the *Northside Neighbor* newspaper to announce the accomplishment. Money was raised through performances, Egyptian Ballroom rentals, donations mailed in, and even with the collection buckets in the Fox lobby. The $131,812 was a great start, but the Save the Fox effort still had a long way to go. Holding the check, just left of center, is Arthur Montgomery. Joe Patten is at center with the glasses. Beauchamp Carr is to the right of him, and Pat Connell is next to Beauchamp. (*Northside Neighbor.*)

104

On March 20, 1976, the Delta Zeta sorority (DZ) hosted "An Evening at the Fox." The extravaganza included more than just an evening. Carolyn Lee Willis (seated) was the chair of the event, which included a men's fashion show and a midnight screening of the 1974 movie *That's Entertainment*. Food stations were set up on all levels of the theater. (Fox Theatre.)

DZ's celebrity guest for the evening was Peter Lupus of the television show *Mission Impossible*. Shown here with prize chairwoman Helen Atwood, Lupus modeled and helped with the commentary as well as donating a week for two valued at $1,000 at the Peter Lupus Leisure World in Panama City, Florida. Tickets for the event were $12.50, and the event raised $80,000. (Fox Theatre.)

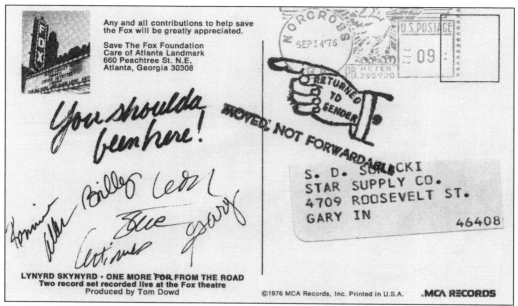

Rock band Lynyrd Skynyrd chose the Fox as its venue for recording its live album in July 1976. *One More from the Road* has been touted as one of the band's best. The group chose the Fox because it liked the acoustics as well as the prestige associated with it. It also wanted to do its part to preserve the theater and sent out this series of postcards to solicit funds. (Fox Theatre.)

Years after being placed in the National Register of Historic Places, a plaque was mounted in the stairwell leading to the Egyptian Ballroom designating the Fox a National Historic Landmark. The distinction by the US Department of the Interior means that the place receiving the recognition is of "historical significance." (Janice McDonald.)

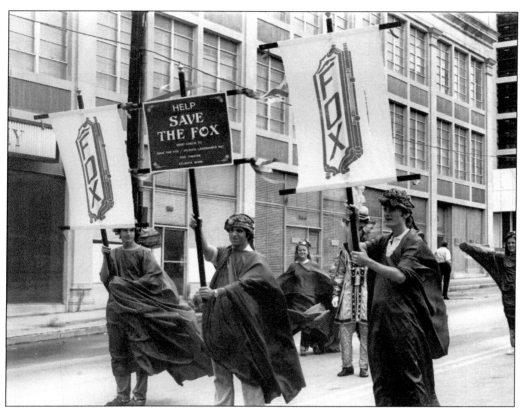

The streets of Atlanta were lined with supporters when, in the summer of 1976, the Save the Fox movement took its message to the public in the form of a parade. By now, the movement was growing and even had some corporate sponsors. Some of Atlanta's biggest philanthropists were digging into their pockets to help. Those marching in the parade included official and unofficial members of Atlanta Landmarks, Inc., as well as the active and vocal Youth for the Preservation of the Fox Theatre. In the photograph above are, from left to right, Tom Champion, Bud Branan, Ashley Wright, Rodney Cook, and Laura Cook. (Both, Rodney Cook.)

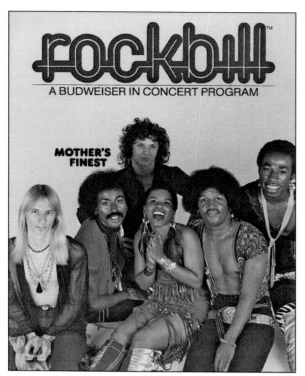

Among the acts playing the Fox was Atlanta's own funk rock group Mother's Finest. Founded by Gary Moore and Joyce Kennedy, it combined heavy guitars with funk rhythm and some blues. Mother's Finest topped the charts in 1977 with songs such as "Baby Love." From left to right are Gary "Moses Mo" Moore, Mike Keck, Barry Borde, Joyce Kennedy, Glenn Murdock, and Jerry Seay. (Fox Theatre.)

Jimmy Carter had run for president in 1976 during the height of the Save the Fox campaign, and as then-governor of Georgia, Carter had voiced support for the efforts. President Carter is shown here in 1977 receiving a Fox T-shirt from Atlanta Landmarks, Inc., board member Beauchamp Carr. (Beauchamp Carr.)

No venue was left untouched by Save the Fox's message. The Goodyear blimp, which is typically hired to fly over large public events with advertising messages, was spotted floating through the skies above Atlanta. Scrolling across the blimp's belly was the mantra that, by now, had become familiar. (Fox Theatre.)

To encourage people to get to know (and love) the Fox, a special series of tours were arranged in June 1977. Prior to these tours, visitors had only really seen what was available while attending a performance. The in-depth tours took guests from top to bottom to show off restoration efforts. Throughout the afternoon, visitors were treated to music by Bob Van Camp on the Mighty Mo. (Fox Theatre.)

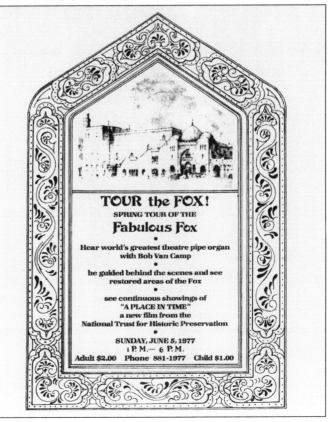

TOUR the FOX!
SPRING TOUR OF THE
Fabulous Fox

•

Hear world's greatest theatre pipe organ
with Bob Van Camp

•

be guided behind the scenes and see
restored areas of the Fox

•

see continuous showings of
"A PLACE IN TIME"
a new film from the
National Trust for Historic Preservation

SUNDAY, JUNE 5, 1977
1 P.M. — 6 P.M.
Adult $2.00 Phone 881-1977 Child $1.00

This is the Youth for the Preservation of the Fox Theatre's ball committee for the 1977 gala. This was the group's third "Wrecking Ball," which was again slated for the Egyptian Ballroom. From left to right are Irene Thomas, Kate Hardin, Peck Brumby, Ann Yauger, Vaughn Coolidge, Rodney Cook, Laura Cook, Bo Hardin, Cam Sorenson, and Connie Sorenson. (Rodney Cook.)

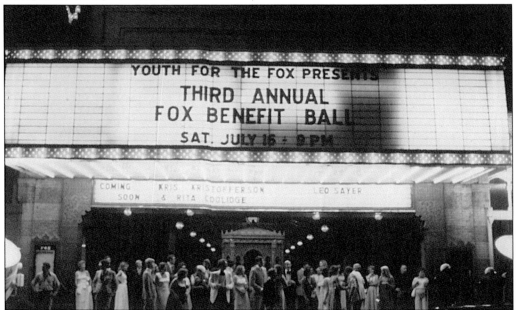

The third benefit ball earned the name "Wrecking Ball." It had become such a popular social event that people would turn out just to witness the arrivals. The organizers treated it like a movie premiere, complete with searchlights and a red carpet welcome. The entertainment schedule that night included the band Sentimental Journey and the Lovett Alumni Chorale. Invitations touted the "Newly Air Conditioned Egyptian Ballroom." (Rodney Cook.)

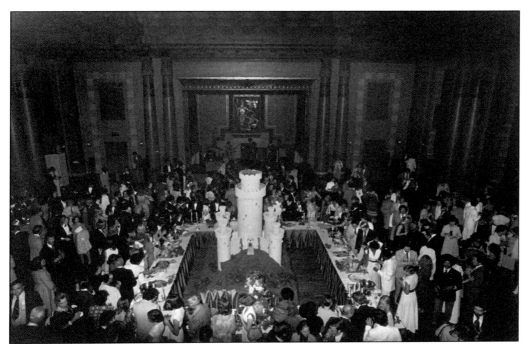

The drive to raise money to pay off the mortgage continued unabated throughout 1977. There were seven interest payments to be made before the final note in June 1978. Due to the succession of galas, concerts, and fund-raisers, Atlanta Landmarks, Inc., was able to regularly make those payments. Robert Foreman would later say that while confident, none of the trustees breathed easily until that last check was written. (Fox Theatre.)

The final mortgage payment on the Fox was due on June 25, 1978, but on February 27, Atlanta Landmarks, Inc., was able to pay the note off a full five months early. Board member Beauchamp Carr sent this letter to Rodney Cook, who had helped lead the Youth for the Preservation of the Fox Theatre. The generosity of the community and sponsors had been overwhelming. There was even one anonymous donation of $400,000. (Rodney Cook.)

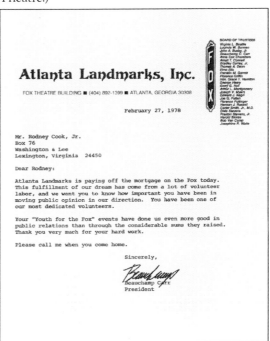

Atlanta Landmarks, Inc.

FOX THEATRE BUILDING ■ (404) 892-1399 ■ ATLANTA, GEORGIA 30308

February 27, 1978

Mr. Rodney Cook, Jr.
Box 76
Washington & Lee
Lexington, Virginia 24450

Dear Rodney:

Atlanta Landmarks is paying off the mortgage on the Fox today. This fulfillment of our dream has come from a lot of volunteer labor, and we want you to know how important you have been in moving public opinion in our direction. You have been one of our most dedicated volunteers.

Your "Youth for the Fox" events have done us even more good in public relations than through the considerable sums they raised. Thank you very much for your hard work.

Please call me when you come home.

Sincerely,

Beauchamp Carr
President

111

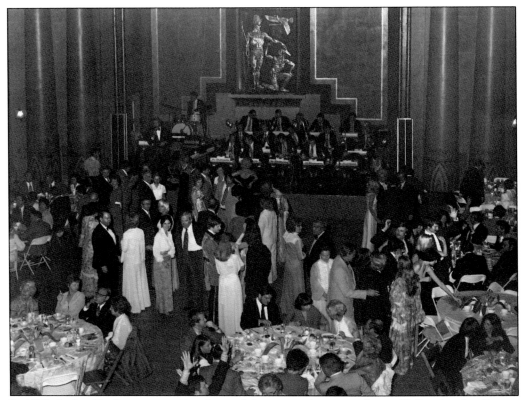

In 1978, Arthur Fiedler was considered one of the top conductors in the world. So when his Boston Pops performed along with the Atlanta Symphony Orchestra for a fund-raiser, the Fox was packed. Fiedler addressed the crowd, saying that the Fox must be preserved because it was important economically, aesthetically, and architecturally. A gala followed the concert. (Fox Theatre.)

This ticket for the Cockroaches concert on June 12 is, in reality, a ticket for the Rolling Stones. The Stones played a series of surprise concerts in smaller venues around the United States in 1978 during their Some Girls Tour. The concerts were announced typically the morning of the performance. To ensure word didn't leak out early, the tickets were printed with the name "the Cockroaches." (Debbie Garner.)

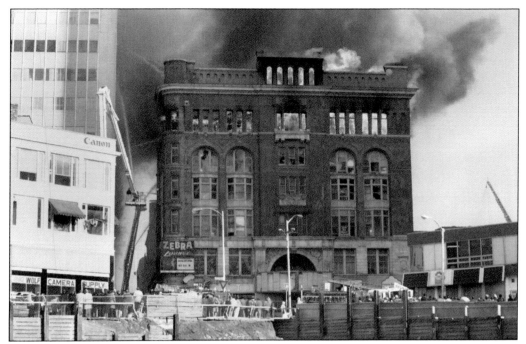

As new life was being breathed into the Fox, the Loew's Grand Theatre was taking its last breaths. Originally built in 1893 as DeGive's Grand Opera House, it was closed in November 1978. Atlanta Landmarks, Inc., purchased its 35mm projectors to replace the Fox's outdated equipment. Fire consumed the upper floors on January 28, 1979. (AHC.)

The structure's integrity was completely damaged by the fire, and the historic building had to be torn down. Given the close call the Fox had been through in recent years, the demise of the Loew's Grand was felt by many. The Georgia-Pacific Tower was later built on its site. (AHC.)

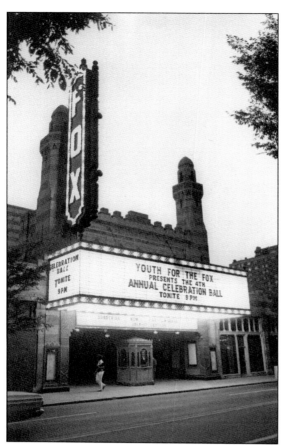

With the Fox's mortgage paid off in full, the Fourth Annual Youth for the Preservation of the Fox Theatre Ball was considered as much a victory celebration as it was a fund-raiser. The theater they'd worked so hard to preserve was saved, and the event took on a whole different atmosphere from previous balls. Some of the organizers arranged a parade of vintage cars through the streets of Atlanta, arriving triumphantly at the Saturday night gala with a police escort. Shown here just outside the theater are, from left to right, Vaughn Coolidge, Rodney Cook, Jody Cook, Paulette Decker, Asa Candler, and Marshall McArthur. (Both, Rodney Cook.)

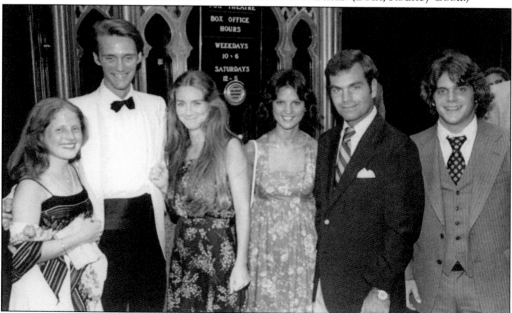

Five

THE FABULOUS FOX

The Fox was reborn and was making a profit. Cash pledges had accounted for almost 90 percent of the moneys that had paid off its debt. The Atlanta community had saved the Fox, and Atlanta Landmarks, Inc., was determined to repay it by hosting performances and events the community would embrace. (Hal Doby.)

In 1978, Southern Bell began work on its telecommunications headquarters building next door to the Fox. The Atlanta-based construction firm FABRAP worked in conjunction with Skidmore, Owings, and Merrill of New York to complete the building in 1980. The new high-rise served as headquarters for both Southern Bell and BellSouth until BellSouth was absorbed by AT&T in 2006. The building, located at 675 West Peachtree Street, was then renamed AT&T Midtown Center. (Fox Theatre.)

While the Southern Bell building was under construction, work was simultaneously underway for the Metro Atlanta Rapid Transit Authority's (MARTA) light-rail system. While the stop was known as the North Avenue station, there was also an exit located in the base of the new BellSouth building, allowing for a convenient stop for anyone who wanted to take MARTA to a Fox event. (AHC.)

THE FOX MEDALLION

A COMMEMORATION OF HISTORY

In 1979, the Fox celebrated its 50th year. To commemorate the event, this bronze medal was commissioned from sculptor Julian Harris. Harris was a German-born Atlanta resident who had also created the 1977 presidential medal for Pres. Jimmy Carter. (Fox Theatre.)

Sharing the Fox's anniversary date is the Atlanta Ballet. In 1979, the ballet also celebrated its 50th anniversary. Part of that celebration included its annual December performances of *The Nutcracker* at the Fox. Since its beginnings, Atlanta Ballet has grown to a nationally recognized professional company with 25 dancers and apprentices. (Atlanta Ballet.)

Joe Patten is shown here accepting a Fox anniversary medal from Julian Harris. In 1980, Atlanta Landmarks, Inc., members Ben Massell and Arthur Montgomery suggested that Patten be rewarded for his tireless preservation efforts by being able to lease the old Shrine area in the Fox as an apartment. Patten had spent virtually every waking moment at the Fox since Atlanta Landmarks, Inc., had taken over the building, and he was now officially its technical director. The Fox Board of Trustees voted unanimously to lease it to him for his lifetime provided he carry out the renovations. Joe Patten became a permanent resident of the Fox in 1982. (Fox Theatre.)

Volunteers have been an important part of restoring and maintaining the Fox. In 1976, a group of volunteers worked alongside Joe Patten to help restore the Fox. In 1979, an official restoration department was established with a full-time staff and director. An archives department was also established so that photographs, memorabilia, and documents would not be lost. In 1985, Jo Ann White and the Atlanta Women's Chamber of Commerce met with general manager Ed Neiss and came up with the concept of "the Friends of the Fox" (FOF). At the first meeting, 30 volunteers showed up to help with whatever was needed, from archiving to cleaning or painting. In the photograph below, FOF member Ed Kuehn paints fountainhead replicas to be used in a membership campaign called "To Be Fabulous." (Both, Hal Doby.)

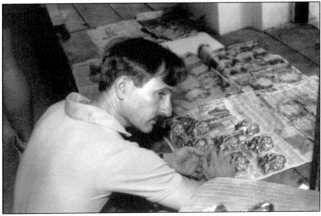

In 1987, a second fund-raising campaign was launched to "Fix the Fox." The $4.2-million drive was organized to fund the Fox's important upgrades and restorations, including a new roof. The plan included returning the Fox's seating to its original configuration. It had been changed when the Fox's orchestral seating area was expanded in 1965. Several rows of seats were removed and replaced with wider chairs. (Hal Doby.)

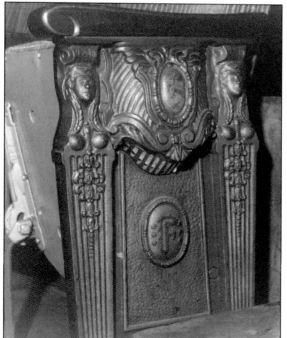

As part of the Fix the Fox fund-raising efforts, people could buy a seat for $250 and have a brass plaque mounted on its arm. Moneys raised up to $250,000 were matched in a challenge grant by the Kresge Foundation of Michigan. Another upgrade included the conversion of former Shrine auxiliary rooms into public spaces. Located on the north side of the atrium, the rooms' walls were removed to become one large space known as the Spanish Room. (Fox Theatre.)

THIS SEAT AT THE FABULOUS FOX

IS TAKEN

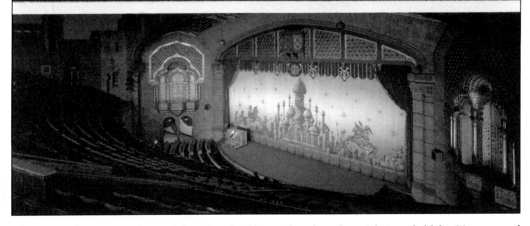

The original seats were located, but they had been abandoned outside in a field for 20 years and were beyond repair. Director of renovation Rick Flinn was able to locate the original manufacturer of the seats and have them replicated, right down to the distinctive "F" on the seat caps. The seat cushions were also recreated to look as they did in 1929. (Both, Richard Bryant.)

...BUT THIS ONE

HAS YOUR NAME ON IT

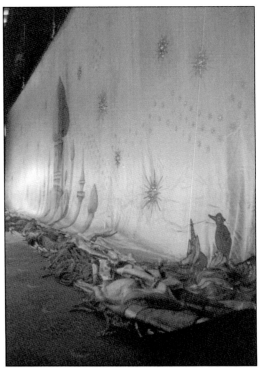

The Fox's distinctive jeweled curtain, which had been specially made for the Yaarab Shriners, was also completely restored so that it could be used again. Joe Patten used his own vacuum cleaner to remove some of the dirt and grime that was on the curtain. Delicate beading and sequins were repaired meticulously by hand. (Richard Byrant.)

In 1989, the Fox hosted the 50th anniversary re-premiere of *Gone with the Wind*. Eleven surviving cast members attended, many of whom were children when the 1939 movie was made. Included are Butterfly McQueen (Prissy), Evelyn Keyes (Suellen O'Hara), Ann Rutherford (Careen O'Hara), Rand Brooks (Charles Hamilton), Fred Crane (Brent Tarleton), Cammie King Conlon (Bonnie Blue Butler), Daniel Selznick (son of producer David O. Selznick), Mickey Keuhn (Beau Wilkes), and Greg Geiss (Bonnie Blue as an infant). (Rhonda L. Cowan.)

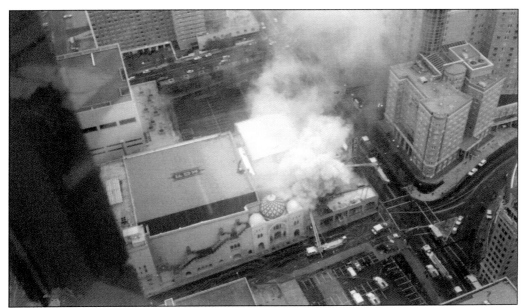

At 5:10 a.m. on April 15, 1996, Joe Patten awoke in his apartment to the sound of fire alarms. The 69-year-old Patten immediately determined it was not a false alarm and rallied the Atlanta Fire Department (AFD) to come save the Fox. Battalion No. 3 was the first to arrive. One hundred firefighters from 12 of the city's 32 stations rushed to the Fox. (Fox Theatre.)

The fire had begun in an electrical junction box in the Adams at the Fox restaurant just below Patten's apartment. The four-alarm blaze could have consumed the Fox if not for three things: Patten's quick action, the AFD's quick response, and lastly, the construction of the Fox. The Fox had been built in stages in the 1920s. The original retail shops and main auditorium were built at separate times and had their own walls. The double brick walls acted as a firewall. (Joe Patten.)

By 9:28 a.m. the fire was under control, and by noon it was declared completely out. Joe Patten was again heralded as the Fox's savior. The Fox was not just his home but his life, and saving it came naturally. While the theater's administrative office suffered damage, the auditorium did not. The Broadway musical *Joseph and the Amazing Technicolor Dreamcoat* was on tour at the Fox and opened that night with no delays. (Joe Patten.)

The fire came just three months before the Atlanta Centennial Olympic Games. The Fox played host to the Australian Olympic organizing committee, which took over the Egyptian Ballroom and Grand Salon areas. The Aussies were paying particular attention to the Atlanta Games, because they would host the next Summer games in 2000 in Sydney. (Fox Theatre.)

When the repairs were completed following the fire, plans were made to create a new terrace outside the Grand Salon. The rooftop patio was designed to overlook Peachtree Street and is accessed from both the salon and the foyer just outside of the Egyptian Ballroom. The terrace extends the space, which can be used for events hosted at the Fox. (Fox Theatre.)

Throughout its history, the Egyptian Ballroom has been a popular venue for weddings, balls, and galas, and now even more so. Jordan Beinstock and his bride, Jennifer Burkett, were married there in 2008 and are pictured here celebrating their nuptials below the marquee announcing their wedding. (Ric Mershon Photography.)

Another change following the fire was the expansion of the Fox's office to include a room specifically for the archives. The Fox archives house materials predating the Fox's existence to the present. The stacks and shelves include photographs, newspaper clippings, films, and artifacts from the Fox, such as remnants of old carpet and drapes, as well as some items apparently lost by patrons over the decades. (Janice McDonald.)

The restoration department offices are located just down the hall from where the archives are housed. The goal of the department is to preserve and maintain the integrity of the Fox. On staff are trained artisans and preservation experts who work constantly to ensure that the Fox stays in pristine condition. The Fox is the only theater in the United States to maintain a permanent staff dedicated to this mission. (Janice McDonald.)

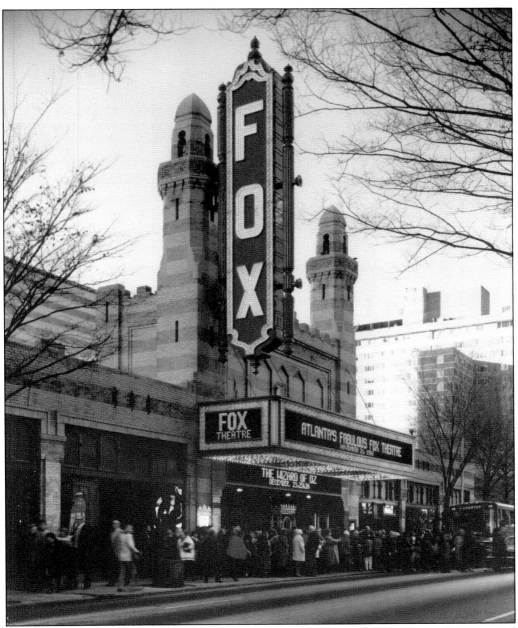

Since Atlanta Landmarks, Inc., took over operations of the Fox in 1975, the theater has operated firmly in the black. It auditorium consistently books 300 performances or more each year, while the Egyptian Ballroom and Grand Salon stay booked well in advance. To play the Fox is considered the pinnacle for many performers. Tours are offered to give visitors context of all the incredible architecture and history found within its walls. For more information regarding tours, please contact the Fox. It doesn't take long to understand why it is listed in the National Register of Historic Places and has been designated a National Historic Landmark. It also is readily apparent why those who know the Fox don't just call it the Fox Theatre. To them, it is simply the Fabulous Fox. (Fox Theatre.)

DISCOVER THOUSANDS OF LOCAL HISTORY BOOKS FEATURING MILLIONS OF VINTAGE IMAGES

Arcadia Publishing, the leading local history publisher in the United States, is committed to making history accessible and meaningful through publishing books that celebrate and preserve the heritage of America's people and places.

Find more books like this at
www.arcadiapublishing.com

Search for your hometown history, your old stomping grounds, and even your favorite sports team.

Consistent with our mission to preserve history on a local level, this book was printed in South Carolina on American-made paper and manufactured entirely in the United States. Products carrying the accredited Forest Stewardship Council (FSC) label are printed on 100 percent FSC-certified paper.

MADE IN THE

USA